Introduction

Charles Rennie Mackintosh is one of Glasgow's instantly recognizable creative geniuses, and his influence on art and design has shaped the identity of the city for over 100 years. The 150th anniversary of his birth in 2018 offers an opportunity to re-examine his influence and impact on the city.

Glasgow is renowned as a city with a remarkable creative spirit in the arts and technology. By the end of the nineteenth century it had become a powerhouse of industrial might, producing the most innovative ships, locomotives and textiles in the world. Much of this success stemmed from the successful integration of science and art into the industrial process. Art and design formed an integral part of the city's booming economy, and Mackintosh grew from this spirit of innovation and creativity.

Mackintosh's talents were nurtured at The Glasgow School of Art and his inspirational collaboration with other artists and craft makers saw the emergence of the Glasgow Style in the 1890s. Glasgow became the birthplace of the only Art Nouveau movement in the UK and its distinctive approach to art, design and craft brought international acclaim.

Charles Rennie Mackintosh Making the Glasgow Style explores this artistic phenomenon using the city's internationally significant museum and library collections, coupled with important loans from The Glasgow School of Art, The Hunterian and other lenders. The vibrant displays of furniture, ceramics, stained glass, metalwork, embroidery, graphics, books, and interiors allow visitors to revel in the fabulous creativity of the artists and discover the importance of making to their work. Based on new research, this exhibition includes many items which have not been seen for a generation or more, and encourages the legacy of Mackintosh and the Glasgow Style to be re-imagined and reinvigorated.

Duncan Dornan,
Head of Museums and Collections, Glasgow Life

Charles Rennie Mackintosh

MAKING THE GLASGOW STYLE

Between the 1890s and 1910s Glasgow, an innovative, ambitious and progressive industrial city, was the birthplace of the only Art Nouveau 'movement' in Britain.

The Glasgow Style grew out of the technical studios of The Glasgow School of Art and the radically original work of a group of bright young things embracing the freedoms of a new Western Aestheticism and educational intellectualism. At its heart was the work of Charles Rennie Mackintosh: architect, designer, artist.

This publication celebrates the 150th anniversary of Mackintosh's birth. It spans his lifetime, presenting his work in the context of his contemporaries, external influences, friendships and like-minded individuals. It places Mackintosh's work in relation to the formation of the Glasgow Style – and his radical stylistic departure from it.

'According to MacNair himself, he first became interested in experimental design when, as an apprentice to John Honeyman, he was thrown back upon his own resources during periods of idleness in the office. On such occasions he used to take illustrations of objects which interested him — chairs for example — place tracing paper over them and try to improve on the original design, or better still, to evolve entirely new forms of his own invention… it was from such beginnings, born of a profound dissatisfaction with the existing order of things, that the so-called Glasgow Style — the Mackintosh style — emerged.'

Charles Rennie Mackintosh, and the Modern Movement by Thomas Howarth, published 1952

High-backed chair for Miss Cranston's Ingram Street Tearooms, 1900
Designed by Charles Rennie Mackintosh, maker unknown
Stained oak, modern horse-hair upholstery
Acquired by Glasgow Corporation as part of the Ingram Street Tearooms, 1950
E.1982.44.1

Mackintosh is best known for his radical high-backed chairs. He simplified historic chair forms by stripping away fussily carved surfaces and elongating the back to exaggerate its height. The result – new, bold, minimalistic design.

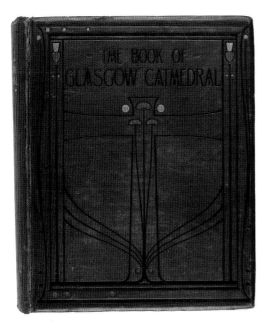

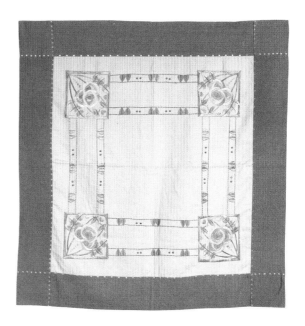

The Book of Glasgow Cathedral, 1898
Cover designed by Talwin Morris, published by
Morison Brothers, Glasgow
Printed and debossed buckram hardcover
Special Collections, The Mitchell Library T-THL 126

Talwin Morris, the Art Director for Glasgow
publishers Blackie and Son, shared his friend
Mackintosh's design principles. Morris's stylish,
commercially produced book covers helped spread
the Glasgow Style worldwide.

Embroidered tablecloth, about 1902–3
Designed and made by Ellison Young
Linen, silk, opaline plastic beads
Given by a private donor, 1980
E.1980.169.7

The first and most continually innovative technical subject
taught at The Glasgow School of Art was needlework.
The department, headed by Jessie Newbery, gained an
international reputation. Through initiatives in teacher
training, this medium popularized and prolonged the
lifespan of the Glasgow Style and its key motifs.

The Glasgow School of Art:
North elevation, March 1897
Designed by Charles Rennie
Mackintosh; office drawing by
Honeyman & Keppie Architects
Photo-mechanical
reproduction, paper, ink,
ink wash; TD1309/A/123-5
Glasgow City Archives

All of Britain's key industrial
cities had an art school. In 1897,
Glasgow invested in a new
bespoke educational building, and
Mackintosh's design, completed
at the end of 1899, reflected the
School's progressive aspirations.
Out of its studios emerged the
Glasgow Style.

1868–1892:
THE YOUNG MACKINTOSH'S GLASGOW

1868: Charles Rennie Mackintosh is born 7 June, in Parson Street, east Glasgow, the fourth of 11 children born to William McIntosh and Margaret Rennie.

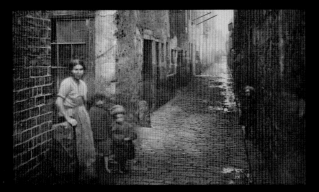

1868: Photographer James Craig Annan documents the slum housing and buildings around the High Street for the Glasgow City Improvement Trust.

1872: The Education Act of 1872 makes school compulsory for all children between the ages of 5 and 12. Mackintosh's generation is the first to experience education as a right for all.

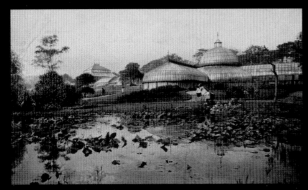

1873: The Kibble Palace glasshouse opens in the Glasgow Botanical Gardens.

1878: Miss Catherine Cranston opens her first tearoom in Glasgow on the ground floor of 114 Argyle Street, under a Temperance hotel.

1882: March: Design reformer Christopher Dresser – the first Western designer invited to Japan in 1876 to observe and advise on manufactures there – lectures on Japanese art, architecture and art manufactures in Glasgow at the Oriental Art Loan exhibition.

1882: Glasgow-educated engineer Henry Dyer returns from Japan where he has worked since 1872 as Principal of the new Imperial College of Engineering, Tokyo. He begins to serve on the governing boards of many of Glasgow's educational institutions to improve vocational and technical education.

1883: Aged 15, Mackintosh starts attending classes at The Glasgow School of Art.

1883, October 6: Foundation stone for Glasgow City Chambers is laid in George Square.

1884: Mackintosh begins a 5-year apprenticeship with Glasgow architect John Hutchison.

1884: Following the 2-year Royal Commission on Technical Instruction, which looked at the value of vocational subjects in elementary schools, an Act of Government is passed making art education compulsory for all children, male and female.

1885: Francis 'Fra' Henry Newbery (b.1853) is appointed Headmaster of The Glasgow School of Art. In his first address he sets out his aims, one of which is to bring more women into the School.

1886: Jessie R Allan, student at The Glasgow School of Art since 1881, becomes the first woman to take on a teaching role there.

1887–89: Walter Crane and William Morris, two of the most important figures in the English Arts and Crafts movement, visit Glasgow to lecture at The Glasgow School of Art's Annual Reunions.

1888: George Walton (b.1867), younger brother of Glasgow Boy painter EA Walton, sets up his own interior decorating business, George Walton & Co. Ecclesiastical and House Decorators.

1888: Glasgow hosts its first International Exhibition in Kelvingrove Park. Construction begins on the fantastical temporary pavilions in 1886.

1889: Mackintosh becomes a draughtsman with newly founded architectural practice Honeyman & Keppie. Here he meets fellow young draughtsman James Herbert McNair (b.1868). Both attend evening classes at The Glasgow School of Art until 1894.

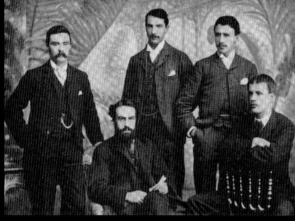

About 1889: Mackintosh (standing, right) and James Herbert McNair (standing, middle) with colleagues from the office of Honeyman & Keppie.

1889: Fra Newbery founds the Glasgow Art Club, a social melting pot of past and present pupils; also marries Jessie Rowat (b.1864), a student at the Art School since 1884.

1890: The Macdonald sisters, Margaret (b.1864) and Frances (b.1873), enrol at The Glasgow School of Art following their family's relocation to Glasgow.

1890: Jessie M King (b.1875) studies anatomy at Queen Margaret Medical College; this is the first year female students are admitted.

1890, September: Mackintosh wins the Alexander Thomson travelling scholarship.

1891: Mackintosh lectures on 'Scotch Baronial Architecture' to the Glasgow Architectural Association in February. Between March and July he tours Italy.

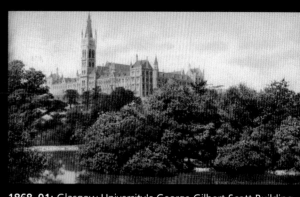

1868–91: Glasgow University's George Gilbert Scott Building is built.

1891–92: Honeyman & Keppie are unsuccessful with their entry to the competition to design the City's new Art Galleries on the edge of Kelvingrove Park.

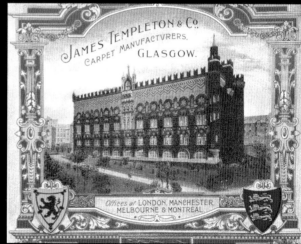

1889–92: William Leiper's Templeton's Carpet Factory is built.

1892: Mackintosh lectures on 'A Tour in Italy' to the Glasgow Architectural Association. This is his first year of life drawing at the Art School. He paints his first known figurative Symbolist watercolour, *The Harvest Moon*.

1892, July: Mackintosh wins a gold medal at National Competition for the design of a chapter house.

7

The Young Mackintosh's Glasgow

Born in 1868, Mackintosh grew up and studied in a Glasgow that was undergoing immense social change and exciting civic expansion. Architectural landmarks – those grandiose, fantastical, structures familiar to Glaswegians today – were being built. Industrial output, international trade, philanthropy, education and artistic engagement conjured a myriad of new experiences and opportunity.

The Corporation Art Galleries, Sauchiehall Street, Glasgow, 1859
Mark Dessurne
Pencil and watercolour on paper
OG.1951.417.be

Between 1877 and 1884 Mackintosh attended Allan Glen's School in Glasgow, where he received high-class scientific and technical training including drawing, woodworking and metalwork. In 1883, aged 15, Mackintosh (then McIntosh) enrolled as a student at The Glasgow School of Art. The School was based in rented rooms on the first floor of the Corporation Art Galleries. Entry was by the ground-floor east-side door on Rose Street – to the right of this drawing. The entrance to the Galleries was through the arched doorway, on Sauchiehall Street.

Collection stand from Dowanhill United Presbyterian Church, 1866
Designed by William Leiper; painted decoration by Daniel Cottier
Painted wood
PP.1982.132.3

From the 1860s architect Leiper and stained-glass artist and interior decorator Cottier
were significant contributors to Glasgow's new and colourful architectural landscape.
When they created Dowanhill Church (now Cottier's Theatre) together as an artistic
collaboration, Leiper was only 26 years old, and Cottier 27. This collection stand
gives an idea of the richly painted and ornamented surfaces throughout the church's
interior.

Caledonia Road Church, Gorbals, Glasgow, 1856
Alexander 'Greek' Thomson
Ink, wash and pencil on paper
Special Collections, The Mitchell Library, Gk T 10

Alexander 'Greek' Thomson was the first 'great' of
Glasgow architecture. His distinctive, monumental,
style was a fusion of forms and detailing derived
from Ancient Greece and Egypt. This was the first of
three extraordinary churches he designed and saw
built in Glasgow between 1856 and 1869.

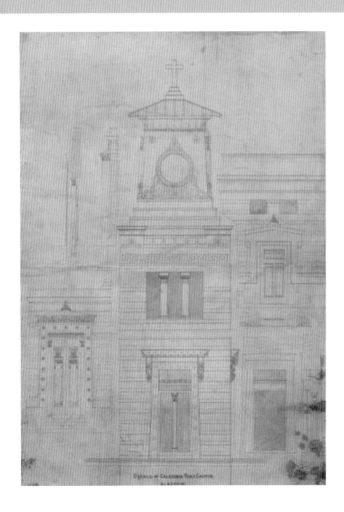

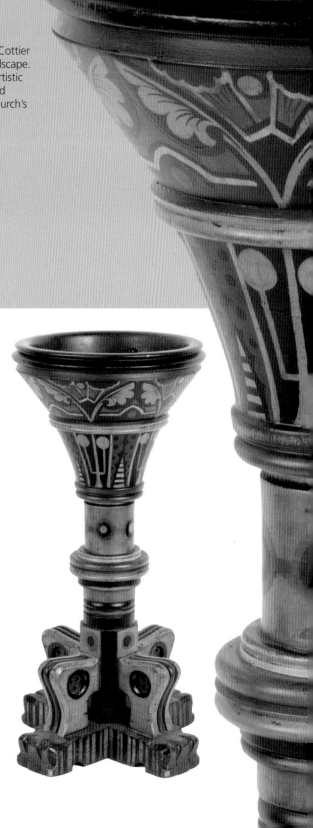

Bringing the Best of Europe's Collections to Glasgow

Glasgow's civic museum collections were formally established in 1870. Kelvingrove House (pictured below) opened in 1872 as the Industrial Museum, a project led by architect James Salmon Senior whilst serving on the City's Parks Committee. Displays were of archaeological, historical and manufacturing objects from home and abroad, as well as natural history specimens.

Drawing from ornament and the Antique was core art school training in Britain, where art education was under the jurisdiction of London's South Kensington Museum (now the V&A). Not all cities had world-class collections, so replicas made by contemporary manufacturers were a cheap way to satisfy the educational market. Glasgow Museums' curator James Paton actively collected for educational purposes, sourcing examples of handicrafts, manufacturing and material samples. He worked particularly closely with those who were leading on art education in Glasgow. The civic collections were made accessible to all students of The Glasgow School of Art for study.

The most important figure in art education in the city was Francis 'Fra' H. Newbery, who was appointed Headmaster of The Glasgow School of Art in 1885. He created social opportunities for networking, and invited important individuals working further afield to lecture. The annual reports of The Glasgow School of Art listing the visiting lecturers, assessors, prize sponsors and its Board of Governors reads like a *Who's Who* of the British Arts and Crafts Movement and Glasgow's business elite. Supporting the School's young talent was an excellent opportunity for manufacturers to help nurture, observe and recruit the best.

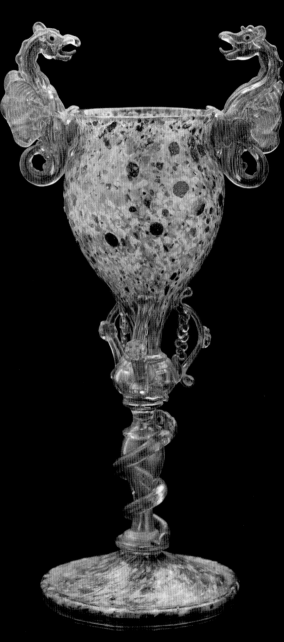

Goblet of Venetian 'variopinto' glass, 1888
Made by Salviati, Venice, Italy
Bought by Glasgow Museums from the manufacturer, 1888
1888.39.b

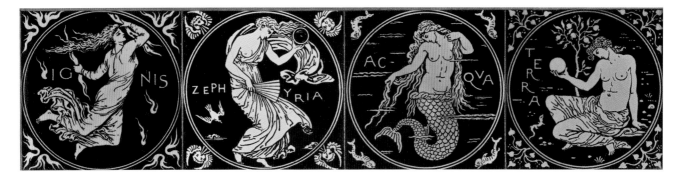

The Elements – Fire, Air, Water and Earth, about 1877
Designed by Walter Crane;
manufactured by G. Maw & Co., Salop, England
Glazed earthenware
Given by G. Maw & Co., 1877
1877.28.bh, .ch, .dh, .eh

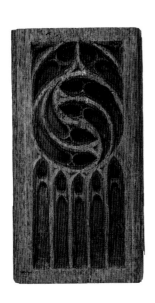

Oak panelling with carved Gothic forms, undated
Unknown maker, probably from France
Bought by Glasgow Museums from Parvillée Frères et Cie, Paris, 1895
1895.136.aa

Reproduction of the 8th century 'Tara Brooch', 1901
Made by Edmond Johnson, Dublin
Metal, gilt, glass
Bought by Glasgow Museums from the Glasgow International Exhibition, 1901
1901.120.v

Casts of old stonework, and reproductions of Celtic metalwork were popular acquisitions with museums. Such replicas allowed students to study the Ancient Celts. Glasgow acquired many such items for its civic collections.

Replica of Ewer, made in Nuremberg, Germany, 1500s
Original in the Louvre Museum, Paris, France
Made by Elkington and Co., Birmingham, about 1878
Copper, gilt
Bought by Glasgow Museums from the manufacturer, London, 1878
1878.143.d

Influence of Japan

In the same year Mackintosh was born, the Meiji (Restoration) period began in Japan; actively opening the country up to Western expertise after being isolated for centuries. Connections between Glasgow and Japan began in October 1872, with a visit by the Iwakura Mission (a diplomatic programme during the Meiji period) to Glasgow's major industrial businesses. A civic reception was held in the Corporation Galleries to welcome them. This visit initiated an intellectual and cultural exchange between Glasgow and Japan, and in November 1878 the Japanese Government's Gift to Glasgow arrived. The gift, packed in 31 wooden cases, comprised of 1,150 items, including fine examples of lacquerware, ceramics, metal ware, textiles, costume, papers, and material samples including leathers, timbers and raw silk. In return Glasgow sent artworks and industrial samples. A number of Scots, particularly engineers, went out to work in Japan.

In 1881–82, the Corporation Galleries held an Oriental Art Loan Exhibition. This temporary exhibition, the first of its kind in Glasgow, displayed 993 loans of Persian and Oriental art. Objects came from across Britain, lent by royalty, nobility, specialist dealers, private collectors and the South Kensington Museum (now the V&A). The Glasgow School of Art, then located in rooms adjacent to the Galleries, devised a programme of study around the Art Loan exhibits.

Japanese cloisonné plate, date unknown
Maker unknown
Copper, cloisonné enamel
Bought by Glasgow Museums, upon closure of the Oriental Art Loan Exhibition, 1882
1882.87

Sheet of Chiyo-gami, 'colourful paper' (detail), 1877
Matsumoto Heikichi, Tokyo, Japan; woodblock carver: Watanabe Yataro; compiled by Takeuchi Hidehisa; publisher: Fukuda Kumajiro, Ukiyo-e, Japan
Woodblock printed on kozo – paper made from mulberry bark
Given by the Japanese Government as part of a cultural and intellectual exchange with the city of Glasgow, 1878
1878.169.jk.84

The opening up of Japan and subsequent exporting of Japanese art gave Westerners a fascinating new visual experience. The flattened, patterned, figurative treatment in Japanese woodblock prints – easily bought in Glasgow in the late 1800s – was to heavily influence Mackintosh and his contemporaries. This design is made up of many small panels of pattern; several are actually humorous cartoons of eyes, animals and people. The patterns come from a comical picture book of 1790 by Santo Kyoden entitled *Komongawa* – 'Elegant Chats on Fabric Design'.

Lidded confectionary bowl, mid 1870s
Made by Miyagawa Kozan, Makuzu workshop, Yokohama, Kanagawa-ken, Japan
Sculpted, enamelled porcelain, gilt
Given by the Japanese Government as part of a cultural and intellectual exchange with the City of Glasgow, 1878
1878.169.bf

This hand-painted lidded bowl is an example of a new type of work produced by one of the premier ceramicists working in Japan. Its delicate floral arrangements, with liveliness added by little gold dots, were definitely studied by some of the Glasgow Style artists.

The Architect's Training

In 1889 Mackintosh joined the newly formed architectural practice of Honeyman & Keppie as a draughtsman. There he met James Herbert McNair, who would become a close friend and artistic collaborator. Honeyman was co-founder of both the Glasgow Archaeological and Glasgow Architectural Societies, and taught his young staff much about architecture and antiquity as they worked with him on projects. Both young architects learnt about the architecture of centuries past through sketching and taking measured drawings of old sites.

After Alexander 'Greek' Thomson died in 1875, the Glasgow Institute of Architects set up a students' Travelling Scholarship in his name. This prize enabled the winner to study abroad. William James Anderson was the first winner in 1887, with a study of Thomson's United Presbyterian Church (pictured opposite left). Mackintosh won the second Thomson Travelling Scholarship in 1890 for 'an original design for a public hall'. He visited more than 23 towns and cities across Italy on his prize-winning grand tour of 1891, filling a diary, sketchbooks and portfolio with notes and drawings.

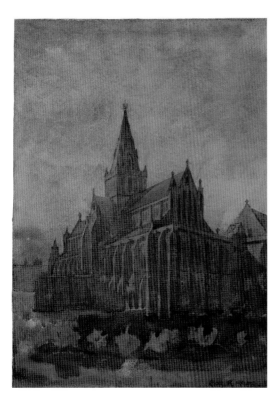

Glasgow Cathedral at Sunset, 1890
Charles Rennie Mackintosh
Pencil and watercolour on paper
From the collections of The Hunterian, University of Glasgow GLAHA 41031

This atmospheric watercolour study of Glasgow's medieval cathedral is of a view Mackintosh would have been very familiar with. From 1874 until 1892 he lived with his family at No. 2 Firpark Terrace, Dennistoun, right next to the Necropolis with the Cathedral beyond.

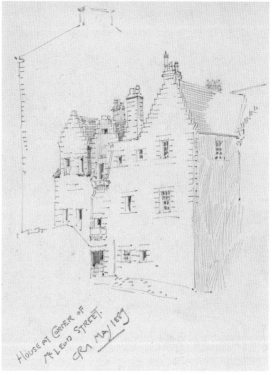

House at Corner of McLeod Street, 1889
Charles Rennie Mackintosh
Pencil on paper
Given by James Meldrum, 1969
PR.1969.12.a

A favourite place for Mackintosh to sketch was around the old buildings of Glasgow located in and around the High Street and the area around the Cathedral. This is Provand's Lordship, built in 1471, the oldest building in Glasgow's city centre.

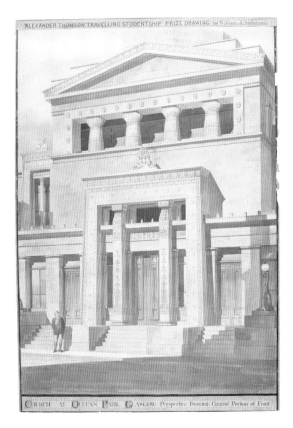

Church at Queen's Park, Glasgow: Perspective Drawing, 1887
William James Anderson
Ink, wash, and paper on linen
Bought by Glasgow Museums with the assistance of the National Fund for Acquisitions and the Friends of Glasgow Museums, 2007
E.2007.9

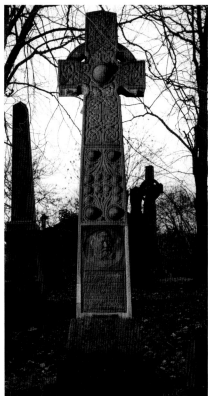

Police Chief Alexander McCall's gravestone in Glasgow's Necropolis, c.1890–91
Designed by Charles Rennie Mackintosh; sculptor James Pittendreigh McGillivrary

Glasgow's Necropolis is the imposing burial ground on the hill behind the cathedral. The young Mackintosh spent time sketching among the elaborate carved stone and cast-iron monuments, many designed by Glasgow's pre-eminent architects. Mackintosh designed this Celtic cross memorial to Police Chief McCall – it was his first free-standing structure. The commission probably came through Mackintosh's father, who was the Chief Clerk to the city's police force and assistant to McCall.

Study drawing: Some Norman Work from Berkshire (detail), about 1884
Talwin Morris
Ink on paper
Given by Mrs Alice Talwin Morris, 1946
PR.1977.13.d

Talwin Morris would become an important figure in the creation of the Glasgow Style. He trained and worked as an architect in England between 1882 and 1890, and was initially apprenticed to his uncle, until 1885, in Reading, Berkshire.

Both Morris and Mackintosh filled notebooks with sketches of interesting buildings and architectural forms, construction, spires and other decorative detailing. Of particular interest were the profiles of doorways and columns and carved and applied ornamentation.

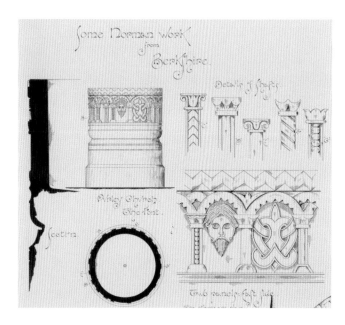

Studying the art of India, Persia and the Middle East: design education

From the mid 1850s – the era of British design reform – many books were written examining the properties of historic and foreign ornamentation. At The Glasgow School of Art, Fra and Jessie Newbery were keen champions of learning from the art and crafts of other countries, particularly Persia, and objects enabling study were actively purchased by learned individuals, such as the Newberys, John Honeyman and John Keppie, and by the City's museums.

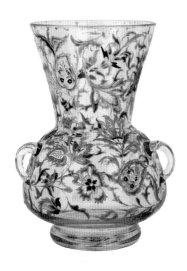

Three-handled vase, about 1870s–80s
Émile Gallé, Nancy, France
Blown glass, hand-painted with enamels and gilt
Bought by Glasgow Museums, 1896
1896.36.d

European makers were learning from Middle Eastern art to create their own fanciful designs. This enamelled vase, an early work by Art Nouveau glassmaker Émile Gallé, is inspired by the shape and enamelled decoration of the glass lamps in mosques.

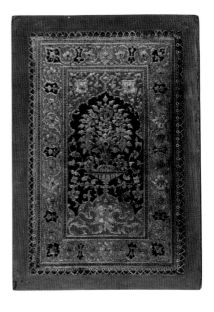

Square Damascus tile, about 16th century
Fritware, polychrome painted, glaze
Bought by Glasgow Museums with a grant from the South Kensington Museum, 1896
1896.37.a.5

The stylized ornamentation on this Syrian tile is derived from native plants and flowers. Such vividly coloured patterns – also seen in carpets and textiles – informed many design exercises by the Art School's students.

Teak wood panel, about 1888
Made in Bikaner, Rajasthan, India
Wood with applied layers of liquid clay, paint, lacquer coating, gold leaf
Bought by Glasgow Museums at the Glasgow International Exhibition, 1888
1888.109.ch

This panel was made by a Rajasthani artisan as an example of work from the Schools of Industrial Art established across India under British Empire rule. The technique is traditional, but the design of the Mogul tree incorporates Persian influences through this new Westernized teaching.

Pencil and watercolour study (detail), about 1891
Charles Rennie Mackintosh
Pencil and watercolour on paper
From the collections of The Hunterian, University of Glasgow
GLAHA:41435

This study by the young Mackintosh is one of two showing the elaborate animal and floral patterning on an Iranian Safavid period (1505/6–1736) Persian pile carpet. It is possible Mackintosh saw the original and sketched it when travelling around Italy.

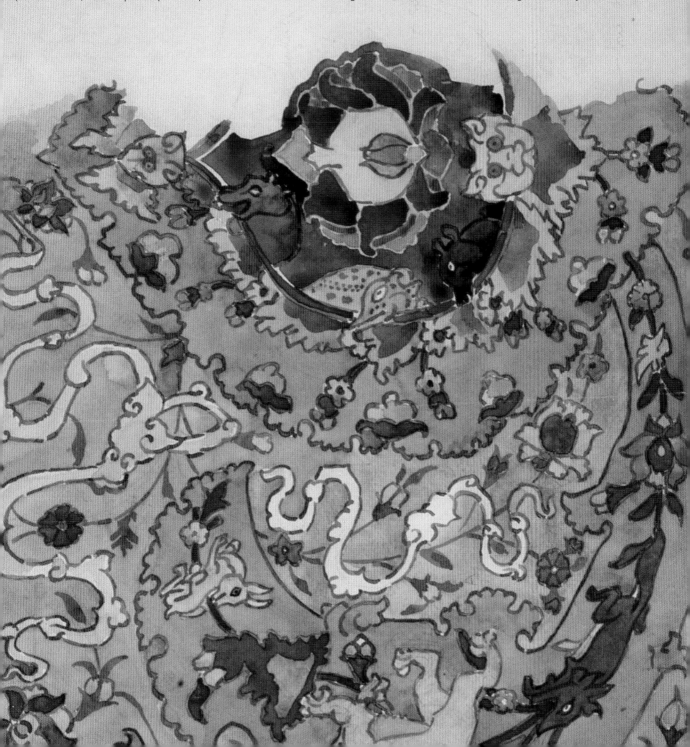

1893–1900:
THE FORMATIVE YEARS
OF THE GLASGOW STYLE

1892–93: At Honeyman & Keppie, Mackintosh's projects include designs for a library at Craigie Hall and a new extension for the Glasgow Art Club. At the latter, his contribution includes figurative, repoussé-brass doorplates and an elaborate repeating stencilled frieze above the picture rail.

1893: Mackintosh and McNair meet the two daytime students Margaret and Frances Macdonald.

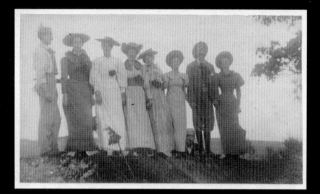

The Immortals, about 1893. Mackintosh and Jessie Keppie are far left, Frances Macdonald, James Herbert McNair and Margaret Macdonald are far right.

1893: Mackintosh appears to assert a new professional identity: he changes the spelling of his name from McIntosh to Mackintosh; and both he and McNair, dressed in artistic attire, have their studio portrait photographs taken by James Craig Annan. In his lecture 'Architecture' he aligns himself with progressive contemporary practice.

A DOOR IN THE HALL.

1893: Sketches by Mackintosh for the Glasgow Art Club (detail).

1893: Mackintosh designs the Glasgow Herald newspaper building.

1893: Mackintosh designs a suite of furniture as a wedding present for his good friend the artist David Gauld.

1893, November: 'The Immortals' produce their first handmade issue of *The Magazine*, edited by Lucy Raeburn.

1894: Mackintosh goes on his first sketching tour around England. He also works on designs for the new Anatomical School at Queen Margaret College.

1894: Miss Catherine Cranston raises a mortgage for £14,000 for the building of her new Buchanan Street tearooms.

1894, November: Work exhibited by The Four at The Glasgow School of Art Club is dubbed 'ghoul-like', 'hideous' and 'The Spook School' by detractors.

1895, January: The Macdonald Sisters exhibit a poster, possibly *Drooko*, at the exhibition of French and British posters at Alexander Reid's Glasgow gallery, La Société des Beaux Arts.

1895: Mackintosh designs Martyrs' Public School for the School Board of Glasgow.

1895: McNair resigns from Honeyman & Keppie to set up his own studio on West George Street, not far from the Macdonald sisters' new studio at 128 Hope Street.

1895, December: The Four exhibit posters at the first exhibition in Siegfried Bing's Paris showroom, La Maison de L'Art Nouveau.

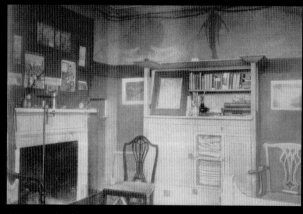

1895: At the family's new home, 27 Regent's Park Square, Glasgow, Mackintosh decorates his bedroom with a stencilled wall design.

1896: Mackintosh, the Macdonald sisters and Jessie Newbery exhibit work in London at the 5th Exhibition of the Arts & Crafts Society.

1896, November: George Walton and Mackintosh undertake the interior decoration of Buchanan Street Tearooms. Mackintosh designs stencilled murals for three floors of the building. The Tearooms open on 5 May 1897.

1897: Mackintosh designs Queen's Cross Church in Maryhill, Glasgow.

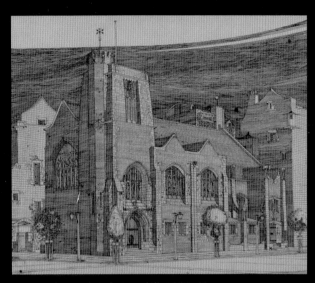

Queen's Cross Church, Maryhill, 1897–99.

1897: Honeyman & Keppie are the winners of The Glasgow School of Art competition. Construction of Mackintosh's building begins on Renfrew Street in November, with the first phase completed by the end of 1899.

1898: Miss Cranston transforms The Crown Temperance Hotel into her new five-floor Argyle St Tearooms. Walton undertakes most of the interior decoration, commuting up from London to oversee the installation. Mackintosh designs the furniture.

1898: Mackintosh's first commission outside Scotland: a dining room for the home of Hugo Bruckmann, editor of the German periodical *Dekorative Kunst*, in Munich, Germany. Margaret Macdonald contributes metalwork panels.

1898: Walton designs the furniture and interiors for the London offices and showroom for the new European headquarters of American camera company Kodak Ltd.

1898: James Herbert McNair is appointed Instructor in Decorative Design at the School of Architecture and Applied Art, University College, Liverpool, a post he holds until 1905.

1898: Mackintosh designs his first white domestic interior for the bedroom at Westdel, for Glasgow publisher and bookseller Robert Maclehose.

1899, July: Talwin and Alice Morris move out of Dunglass Castle in Bowling, Dunbartonshire, and the Macdonald family move in.

1899, June 14: Frances Macdonald and Herbert McNair marry at St Augustine's Episcopal Church, Dumbarton. The McNairs set up home in Liverpool.

1900: Mackintosh works on the designs for the Daily Record building, Glasgow, and becomes sole designer for Miss Cranston's Ingram Street Tearooms.

1900: The Mackintoshes design and decorate their future marital home at 120 Mains Street, Glasgow, furnishing it with many examples of his tearoom furniture.

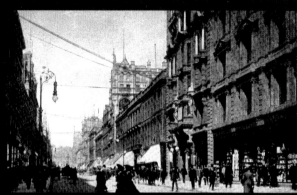

Buchanan Street, Glasgow, about 1900.

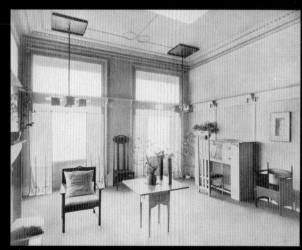

The Mackintoshes' marital flat, 120 Mains Street, Glasgow, 1900.

1900, August 22: Mackintosh and Margaret Macdonald marry at St Augustine's Episcopal Church, Dumbarton.

1900: Sylvan McNair, the only child of Frances and James Herbert McNair, is born.

1900, October: The Mackintoshes travel to Austria to install their room at the Eighth Exhibition of the Vienna Secession, 3 November–27 December. Talwin Morris exhibits a bronze mirror frame.

The Shock of the New

'The long hair, soft felt hats and big bow ties of the men; the Aesthetic attire of the damsels, and the flat japanned boxes of both proclaim them Art Students.'

Anonymous author writing into the Glasgow Evening Times, *Nov 1894*

By the close of 1893, a number of events had occurred that ignited the Glasgow Style: Talwin Morris moved to Glasgow to take up the position of Art Director at publishers Blackie & Son; the Technical Art Studios were founded at The Glasgow School of Art; and *The Studio* magazine, a new British art periodical, created ripples with the publication of an essay on the drawings of Aubrey Beardsley.

Most significantly, sometime that year Mackintosh and fellow draughtsman James Herbert McNair, evening students at The Glasgow School of Art, were introduced – possibly by Director Fra Newbery – to the daytime students and sisters, Frances and Margaret Macdonald. 'The Four', as they became known, were part of an artistic social circle nicknamed 'The Immortals'. It was a time of meeting of minds.

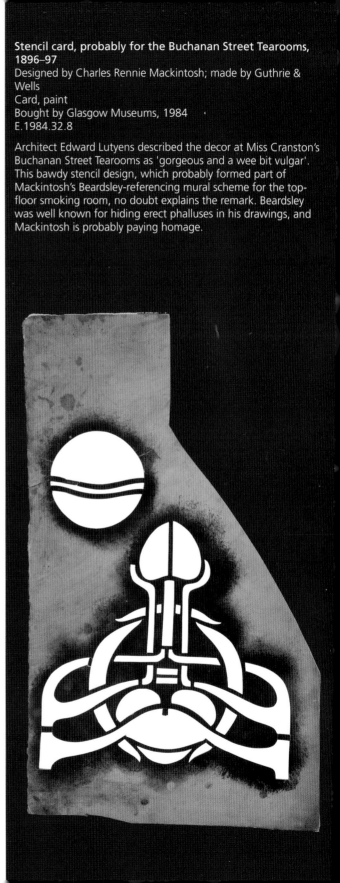

Stencil card, probably for the Buchanan Street Tearooms, 1896–97
Designed by Charles Rennie Mackintosh; made by Guthrie & Wells
Card, paint
Bought by Glasgow Museums, 1984
E.1984.32.8

Architect Edward Lutyens described the decor at Miss Cranston's Buchanan Street Tearooms as 'gorgeous and a wee bit vulgar'. This bawdy stencil design, which probably formed part of Mackintosh's Beardsley-referencing mural scheme for the top-floor smoking room, no doubt explains the remark. Beardsley was well known for hiding erect phalluses in his drawings, and Mackintosh is probably paying homage.

Salomé: J'ai baisé ta bouche, 1893
Aubrey Beardsley
Published in 'A New Illustrator – Aubrey Beardsley' by Joseph
Pennell; *The Studio*, Issue 1, April 1893
Printed paper, first edition, leather-bound
GML.2017.1

The Studio magazine's first issue showcased Beardsley's
strikingly original drawings. This illustration for *Salomé* was
Beardsley's response to the soon-to-be-banned play by Oscar
Wilde. His radically stylized drawing drew enormously from
pictorial devices in Japanese art; sinuous curves, simplification
of forms, patterned surfaces contrasting with the art of
absence – dramatic, negative space. It was one of 17
illustrations Beardsley drew for *Salomé*'s British publication
in 1894, and had a profound effect on the young Glasgow
artists.

Poster for Drooko Umbrella Factory, Glasgow, 1894-5
Designed by Frances Macdonald and Margaret Macdonald
Facsimile print from an original photograph
From the collections of The Hunterian, University of Glasgow
GLAH 52932

Only a photograph survives of this important early poster
by the Macdonald sisters. Without a doubt the elongated
composition and not-so-feminine female figure draw upon
Beardsley's *Salomé*. The poster is also a good example of
the plant symbolism The Four embraced in their work. The
umbrellas the poster advertises are referenced through the
presence of the stylized giant hogweed, a member of the
Umbelliferae family.

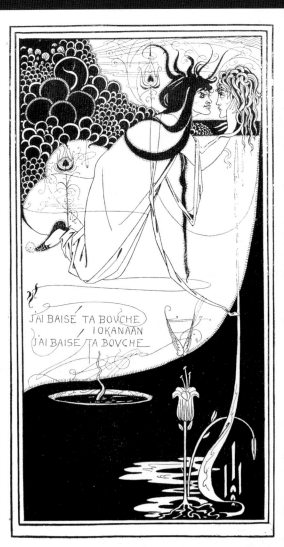

FROM A DRAWING IN ILLUSTRATION OF MR. OSCAR WILDE'S "SALOME"
BY AUBREY BEARDSLEY

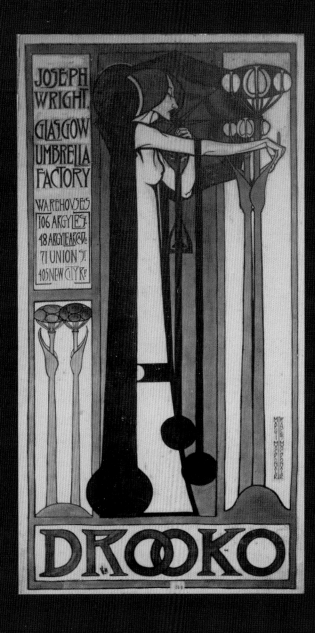

Poster for the Glasgow Institute of Fine Art, about 1894–95
Designed by Charles Rennie Mackintosh; printed by Carter and Pratt, Glasgow
Planographic, lithographic, print on four joined sheets of paper
From the collections of the The Hunterian, University of Glasgow
GLAHA 52978

When these posters were exhibited in early 1895, critics derided them as 'human beings drawn on the gas-pipe system'. Some felt so strongly about the weird designs that they sent in comedic poems to the letters columns of the local press. However these early experiments in a bold graphic art form a manifesto for The Four's radical new style: the elongated treatment of the human figure, the framing devices of stylized plant forms, symbolic motifs and, most importantly, the proportional division of the picture plane for the arrangement of the design.

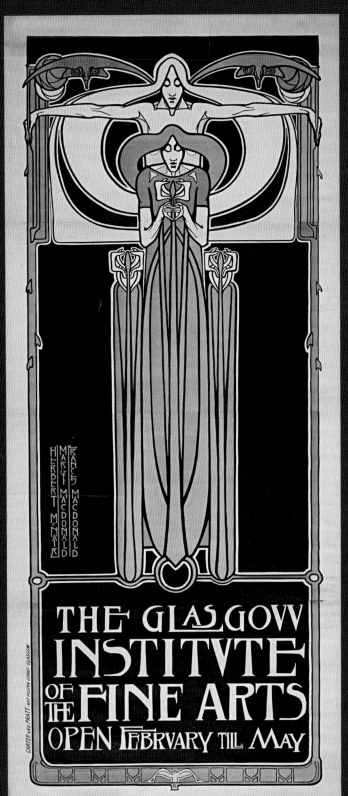

Poster for the Glasgow Institute of Fine Art, about 1895
Designed by Frances Macdonald, Margaret Macdonald and
James Herbert McNair; printed by Carter and Pratt, Glasgow.

'The Poster's Mission', or 'Why I signed the pledge'

One day as I gazed at a hoarding
My soul was filled with dread
For I looked on an Art School Poster
A poster comprised of a head
With lines attached that seemed to fall
In somewhat aimless ways –
It was the crazy Aubrey Beardsley
No – the Aubrey Beardsley craze.

But no I thought, 'tis no Woman
'Tis a map of the new subway
With the down lines red, and the up lines black
Made in a style to pay
What I took for the head is the City
And the staff is the mileage scale
Yet I felt my words were idle
For I feared 'twas no plan of the rail[i]

That night I returned from a concert
Of a scarcely clerical kind
And I gaze again at the hoarding
Great Whistler! What horrors I find –
A two-headed serpentine dancer
Most ghoulishly grins down at me[ii]
I've got 'em[iii] again cried I wildly,
So that's why I became T.T.[iv]

Published in *The Quiz*, 21 February 1895

[i] This verse is describing Mackintosh's poster design
[ii] The poster by the Macdonald sisters and McNair
[iii] probably referring to the vapours or melancholy
[iv] Teetotal, abstaining from alcohol

Poster for the Glasgow Institute of Fine Art, about 1895
Designed by Frances Macdonald, Margaret Macdonald and
James Herbert McNair; printed by Carter and Pratt, Glasgow
Planographic, lithographic, print on four joined sheets of
paper
Presented by Mrs Alice Talwin Morris, 1939
PR.1977.13.au

The posters reveal the evolution of ideas during 'The Spook
School' period (as the press derisively named the style).
Figures are half hidden by plant stems, suggesting they grow
from the same seed. Here an early appearance is made by
both the Glasgow rose and the arc-ed flying bird.

The influence of Japan upon the work of Mackintosh and The Four is often commented upon. These pages suggest a few Japanese objects, books and motifs that were in general circulation in the late 1890s and would have been easily accessible to these young artists as they shaped their ideas.

Iroha-biki mon cho – Book of Crests in Syllabary Order, 1881
Edited by Tanaka Kikuo; published by Kyukodo, Tokyo, Japan
Woodblock printed paper, thread
Given by the Dyer family, 1924
Special Collections, The Mitchell Library 323774

Kamon, the crests of Japanese families, were applied to property and clothing. The variety of designs is immense: geometric, spirals, plants. Seeing a little book like this could have inspired Mackintosh's radical stylizations from the mid-1890s and influenced his first-known stencil designs for Miss Cranston's Buchanan Street Tearooms.

Stencil cards for a mural, Buchanan Street Tearooms, 1896–97
Designed by Charles Rennie Mackintosh; made by Guthrie & Wells
Card, paint
Bought by Glasgow Museums, 1984
E.1984.32. 6 & .7

These two stencil cards are for a repeating scheme of five stylized totem-like trees that ran along the south wall of the Luncheon Room. The trees stood between regularly spaced pilasters that were stencilled with large flamboyant peacocks. The canopy of each tree is a tangle of organic lines, Celtic ornament, leaves, buds and flowers.

Stencil design requires the artist to think with a pared-down simplicity in order to create the layered coloured cut-outs. Each of these stencil cards has had the black outline for its corresponding tree stencilled onto it as a guide. The traces of paint on these cards and the surviving coloured design drawings indicate Mackintosh employed a dark palette of strong, vibrant colours, olive and acid greens and gold.

24

Poster for the Scottish Musical Review, 1896 (right)
Designed by Charles Rennie Mackintosh; printed by Banks & Co.,
Edinburgh and Glasgow
Planographic, lithographic, print on four joined sheets of paper
Presented by Mrs Alice Talwin Morris, 1939
PR.1977.13.ar

Mackintosh's advertising poster, with joyous singing birds, takes the
idea of the human-plant hybrid to its most abstracted manifestation.
Along the top he plays with shapes to create unearthly totems.
Are they plants? Symbols? Those mysterious green forms resemble
the metal cut-outs he later employs on the railings of The Glasgow
School of Art.

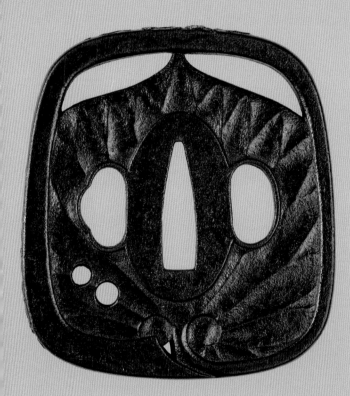

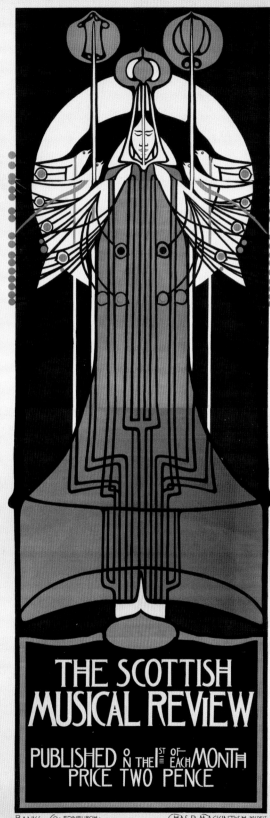

Tsuba – Japanese sword guard, possibly 17th–18th centuries
Design: Lotus, by the School of Kaneie
Iron, silver
Bought by Glasgow Museums, 1895
1895.44.ca

A *tsuba* is the decorative metal guard made for a Japanese sword,
and serves as the barrier between the hand grip and the blade.
Crafted by specialist artisans, they became popular collectables.
This *tsuba* shows a lotus flower – a favourite Japanese motif. It is
one of many acquired by the City's Industrial Museum in 1895. Did
tsuba influence Mackintosh's cut-out designs? Did Talwin Morris
also see this on display in the Museum? The asymmetrical placing
and spacing of the plant curl and holes resembles his later signature
change to three distinctive dots.

Early Masterworks

'Those who want to see art should bypass London and go straight to Glasgow. Glasgow's take on art is unique. In architecture, it is a new, young city.'

German architect Hermann Muthesius, Dekorative Kunst, *1902*

While Mackintosh was forging new friendships and his innovative graphic style, he was also working extremely hard as an assistant in the architectural offices of Honeyman & Keppie. New city-centre buildings, interior decoration and furniture design gave him a three-dimensional opportunity and outlet to develop his visual language and hone his imagination. By the age of 31, the breadth of his architectural and design achievements was extraordinary.

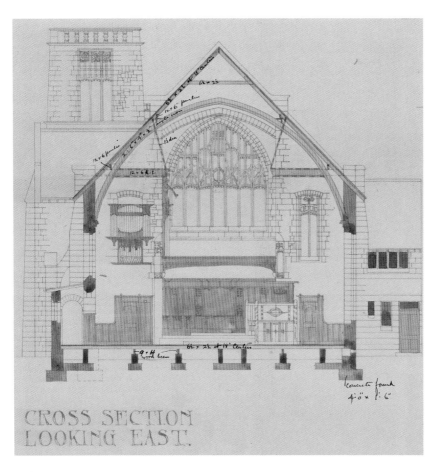

CROSS SECTION
LOOKING EAST.

Queen's Cross Church, cross section looking east (detail), April 1897
Designed by Charles Rennie Mackintosh, 1896–97; office drawing by Honeyman & Keppie
Photo-mechanical reproduction and wash with ink
Glasgow City Archives
TD1309/A/122-

Mackintosh's only built church is on Maryhill's Garscube Road. This working drawing shows ideas in development; many details shown here were not built. He refined his final design with restrained decorative carvings in wood and stone depicting stylized seeds, plants and long-winged birds.

The Early Tearoom Designs

We don't know who brought Mackintosh in to work alongside interior decorator and art furnisher George Walton at tearoom entrepreneur Miss Catherine Cranston's Buchanan and Argyle Street tearooms – was it Walton himself or was it Miss Cranston? At Buchanan Street, Mackintosh provided three New Art mural schemes as a backdrop to Walton's elegant furnishings and fittings. At Argyle Street, Walton's richly patterned and textured surfaces – stencils, printed textiles and leaded glass and copper panels – provided the backdrop to Mackintosh's imposing furniture. Their distinctly different aesthetic styles created an interesting synergy, and provided Glasgow with a cutting-edge dining experience.

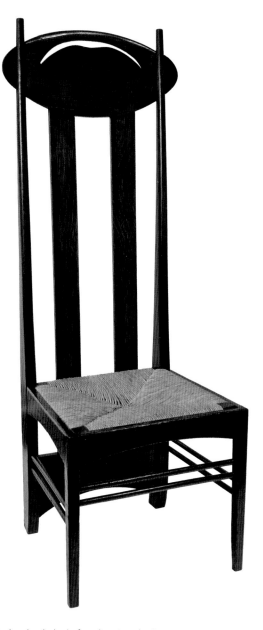

Table for the smoking room, Argyle Street Tearooms, 1898
Designed by Charles Rennie Mackintosh; cabinetmaker unknown
Polished oak
Acquired by Glasgow Corporation as part of the Ingram Street Tearooms, 1950
E.1982.58

Worn from years of use, the table shows the robustness of Mackintosh's furniture for these tearooms. Its solidity is lifted by the deep curves of the apron. Subtly carved and pierced decoration alludes to plant forms or germinating seeds.

High-backed chair for the Argyle Street Tearooms, 1898
Designed by Charles Rennie Mackintosh; cabinetmaker unknown
Stained oak, modern upholstery
From the collections of The Glasgow School of Art

This was the first high-backed chair Mackintosh designed. It is now iconic because its imaginative design – conjured up in Mackintosh's head 120 years ago – is so ahead of its time. The long, straight back invites good posture. The oval, cut with the arc of a stylized flying bird, frames the user's head.

27

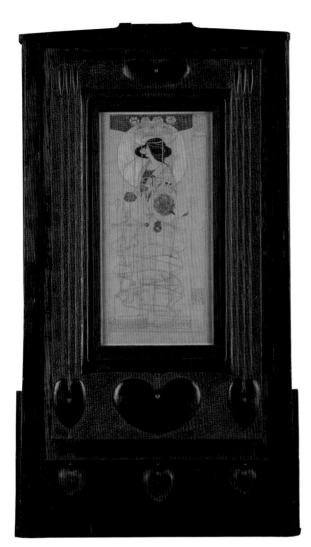

Part Seen, Imagined Part, 1896
Charles Rennie Mackintosh
Watercolour, pencil, tracing paper, gold pigment
PR.1977.13.aq

Repoussé frame, about 1896–1899
Designed and made by Talwin Morris
Stained wood, lacquered repoussé metal, glass cabochons
E.1939.55.a
Given by Mrs Alice Talwin Morris, 1939

This enigmatic figure with her whiplash hair and kimono gown references the influence of both Japan and Art Nouveau. The figure emerges from the ground from a tangle of plant stems. She is only partly visible, colour is added as her body takes form. The pencil line on this drawing is not a sketch, it is one continuous traced line, indicating that this is Mackintosh working up an idea made over another work. He exhibited this drawing at the 5th Exhibition of the Arts and Crafts Society in London in 1896.

Possibly *Part Seen* is a tracing made over his larger design drawing for decoration for Miss Cranston's Buchanan Street Tearooms. In his mural scheme for the Luncheon Room there, a procession of these statuesque women, surrounded by strange plant forms and trees, towered over diners. Stencilling was a cheap and popular way to decorate large expanses of wall. Mackintosh excelled in this art form; it perfectly suited his bold graphic style and it was quickly becoming an important part of his interior designs.

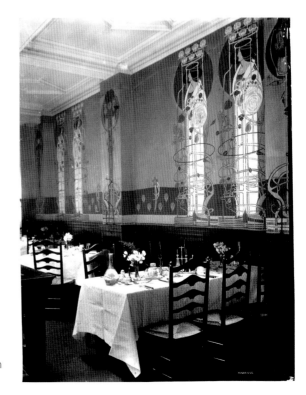

Mackintosh's Luncheon Room mural in Miss Cranston's Buchanan Street Tearooms.

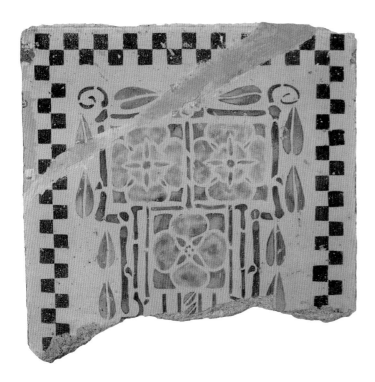

Stencilled plaster fragment from the Argyle Street Tearooms, 1898
Designed and made by George Walton & Co., Ltd
Painted plaster
Gifted by Legal & General Property Limited, 1990
E.1990.41.2.a & .b

This fragment is from Walton's ceiling decoration at the Argyle Street Tearooms, where lengths of its stencilled surface ran along the underside of the support beams. Richly patterned, its colourful soft florals, thorned stems and leaves are interestingly offset by a bold black and white chequerboard edge.

Stencilled wall section from the Ingram Street Tearooms, 1900–01
Designed by Charles Rennie Mackintosh; stencilling probably by Guthrie & Wells
Plaster, wood (lathe), cement, paint
Acquired by Glasgow Corporation as part of the Ingram Street Tearooms, 1950
E.2018.1.1

This section of plaster wall comes from a low-ceilinged tearoom located to the upper rear of the Ladies' Luncheon Room at the mezzanine-level. The plain painted walls were punctuated at intervals with this tall stencilled rose bush.

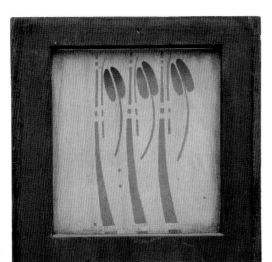

Stencilled panel (detail) from the Billiards Room, Ingram Street Tearooms, 1900–01
Designed by Charles Rennie Mackintosh; stencilling probably by Guthrie & Wells
Stained wood, paint
Acquired by Glasgow Corporation as part of the Ingram Street Tearooms, 1950
ISTR.14.E.13

The panelled walls of the first basement Billiards Room at Ingram Street, directly under the Ladies' Luncheon Room, were decorated with this stencilled design. It appears to depict a row of budding tulips, but could also allude to a rack of snooker cues – or more cheekily – the masculine domain of gaming.

Kindred Spirits

'…this little group of workers is distinct. They together stand alone, and so happily escape classification… their art is for the artist and thinker. From their hands we have poems…'

Talwin Morris, Manuscript: 'Concerning the work [of The Four]', about 1897

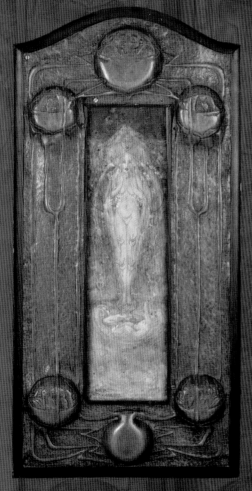

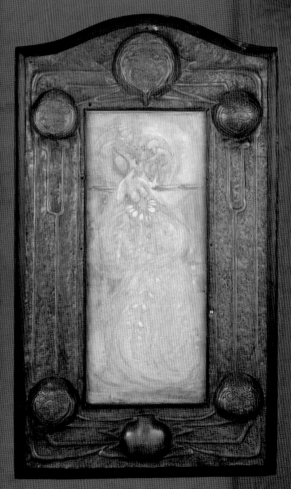

Spring, 1897
PR.1977.13.c (watercolour); E.1939.55.e (frame)

Spring – the season of rebirth. Frances expresses growth, life and a frisson of anticipation. Two figures, crowned in blossom, stand above two babies under the soil. The proceedings are watched by a series of floating black eyes. In the frame, five nests of baby birds clamour to be fed.

Summer, 1897
PR.1977.13 (watercolour); E.1939.55.b (frame)

Summer is the season of fertility and full flower. A pregnant woman, clothed in yellow roses, leans back to face four babies reaching out to her. Three silhouetted swallows speed across the sun and scene at chest height. In the frame, five flowers are pollinated by bees.

The Seasons, 1897–98

These four panels were made by the Macdonald sisters at their studio at 128 Hope Street, Glasgow. They worked simultaneously, one panel each: Spring (Frances) and Summer (Margaret), then Autumn (Frances) and Winter (Margaret). Each season is symbolized by motifs placed in the roundels of its lead frame. Their approaches were not identical; Frances chose to execute Spring and Autumn in a narrower format, and the construction and design of the frames differ between the pairs made. The panels were given to Glasgow Museums by Talwin Morris's widow, Alice, in 1939.

All watercolour on vellum, repousse lead, stained wood.

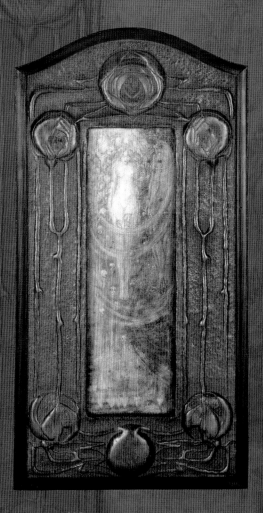

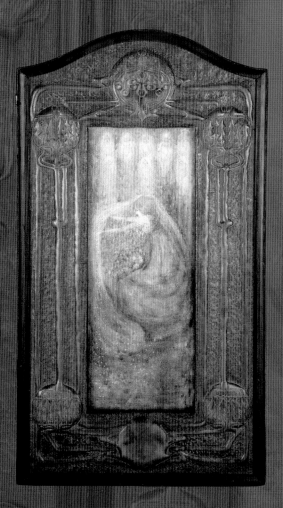

Autumn, 1898
PR.1977.13.a (watercolour); E.1939.55.c (frame)

Autumn is the season of death, decay and loss. Two separated figures, one front-on, one in profile, hover like ghosts amongst berries and faded roses. At their feet skull-topped posts grow from a row of hearts. The plant stems on this frame are the only one that bear thorns; the roundels are roses, each contains a weeping face of grief.

Winter, 1898
PR.1977.13.b (watercolour); E.1939.55.d (frame)

Winter, the hardest, darkest, season of the year. Nature waits: ghostly, motionless children float above the scene like expectant spectators. The only motion is the scattering of snowdrops from the woman's hands. In the frame are holly leaves with berries and a sprig of mistletoe.

A deep sense of mystery, stillness and calm emanates from The Four's highly symbolic drawings and watercolours. To gaze at their work is to enter another world, to – as German architect Herman Muthesius so eloquently described it – 'breathe within their reality'. The Four created a very distinctive, personal response to the broader mythological interests and allegorical expressions popular with many young artists, poets, composers and writers working in the later nineteenth century.

Their enigmatic narratives are also experiments in making. These two works are created by over-layering drawings and media and integrating the frame into the design to form a complete artwork.

The Lily's Confession, 1897 (right)
James Herbert McNair
Pastel, pencil and gold ink on lens tissue, pastel, pencil and stain on yellow pine, stained wood frame
Given by Mrs Alice Talwin Morris, 1946
PR.1977.13.t

McNair builds the ghostly, delicate image in this experimental drawing by layering. Colour applied to the wooden backing board shows through the exceptionally thin, translucent paper – a lens tissue – of the drawing. He applied a dark stain to the wooden panel to give depth, and uses the natural warm tones of the wood, and pastel highlights to give luminosity to the figure's flesh and to the crescent moon. He enhances the shimmering transience of the scene by his choice of applied media on top of the tissue: pencil, gold ink and light pastels.

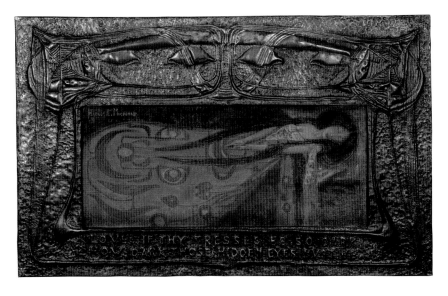

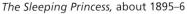

The Sleeping Princess, about 1895–6
Frances Macdonald
Pastel, pencil, watercolour, tracing paper, paper, silvered copper, wood
Given by Mrs Alice Talwin Morris, 1946
PR.1977.13.u (pastel) E.1946.5.f (frame)

The motto on the frame is from Tennyson's 1842 poem 'The Day-Dream'; they are the words uttered by the prince when he first sets eyes upon the sleeping beauty. Frances faithfully takes Tennyson's description of the princess as her starting point. Her imagining of his 'silk star-broidered' quilt pre-empts the fabric patternings of Gustav Klimt. This is Frances's only known chalk pastel drawing, and it is on tissue paper – not a traditional combination of media. Her unusual choice became clear during conservation work; adhered below the chalk pastel layer a precise pencil on paper outline drawing of the composition was revealed. Presumably her choices of media were to guide her hand in a less familiar, and more bulky, medium.

Caprice, undated, about 1902–5
James Ferrier Pryde
Ink, watercolour, gouache on paper
Presented to Glasgow Museums by subscribers through Charles Rennie Mackintosh, 1906
1152

Many of the people associated with the Glasgow Style gave objects to Glasgow's civic collections over the years; often interesting objects that took their eye and which give us a little insight into their tastes and interests. Mackintosh was behind the City's acquisition of this work by his friend, Edinburgh-born artist James Pryde, for its collections. It was effectively a 1900s' version of crowd-funding – purchase by public subscription – with Mackintosh as the nominator. This was a frequent route for more unusual works, not selected by the museum staff and committees, to come into the collection. Pryde's sinister depiction of grotesque characters and rogues in Dickensian dress combined with the work's half-finished quality makes it a very interesting choice for Mackintosh to consider presenting. The clothing of the female figure on the right invites comparison with the full-skirted women favoured by The Four.

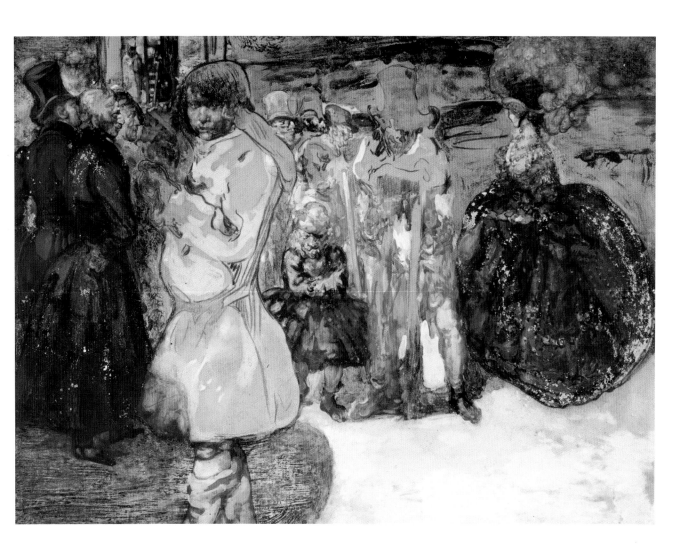

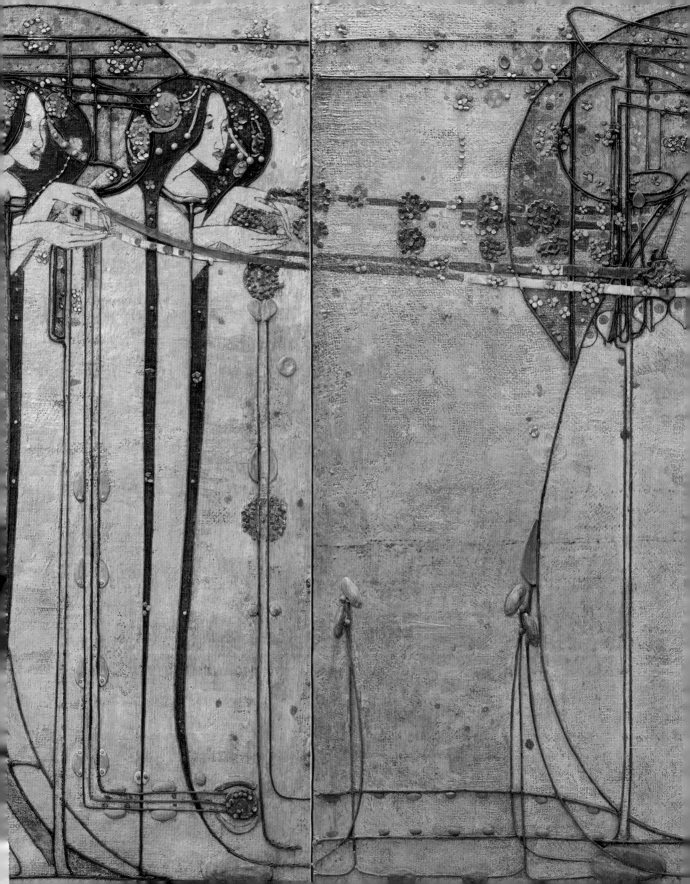

Margaret Macdonald Mackintosh, sitting in a high-backed chair, photographed about 1900.

The May Queen, **1900**
Margaret Macdonald Mackintosh
Gesso on hessian over a wood frame, scrim, twine, glass beads, thread, mother-of-pearl, tin leaf, metal pins
Acquired by Glasgow Corporation, as part of the Ingram Street Tearooms, 1950
E.1981.178.1–3

Margaret Macdonald's development of the Glasgow Style figure culminates in this gesso frieze of 1900. Theatrical in its construction, this panel was designed to be viewed high up, like a Byzantine mosaic.

The May Queen by Margaret, and its partner panel *The Wassail* by Mackintosh, were the couple's first attempt to work in the gesso medium and were made around the time of their marriage in 1900. They worked on the panels together in the evenings, a process that Mackintosh described as being most agreeable: 'We are working on them together and that makes the work very pleasant. We have set ourselves a very large task…'.

Large indeed; *The May Queen* is a total of 4.5 metres long and comprised of three separate panels each 1.5 metres square, making it easier to handle, pack and transport. It is highly textured and quite crude in technique, almost like something produced for a theatrical stage set. A loose-weave hessian is stretched over a wooden structure and embedded with a roughly applied gesso (a fine plaster that must be worked whilst wet and pliable) over scrim to make a solid, textured surface. The outlines of the figures, trees and plant forms are drawn by brown painted household string. The string was held fast into the drying gesso by long steel pins. These pins still remain, protruding by an inch or more from the back of the canvas.

The addition of glass beads and shaped plaster blocks pressed into the surface create the panel's textured detail and decoration. If you look very closely, you can see Margaret's finger prints on some of these gesso pips and petals.

The surface colouring of the panel is sophisticated and yields a number of surprises; oil paint is applied in a fluid Impressionistic manner and metallic leaf and pigment is applied to the May Queen's bodice to add sparkle. The right-hand females are pallid in complexion because their skin is made of an applied papier maché. The reason for Margaret choosing not to finish all of the figures in this way is unknown.

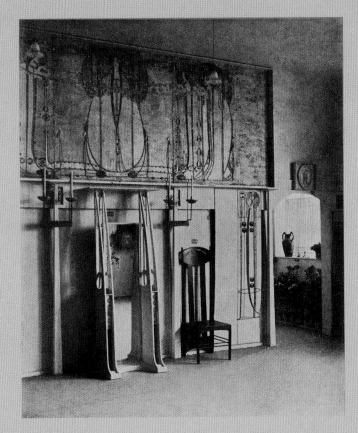

After completion *The May Queen* and *The Wassail* were shipped to Austria where they were unveiled as the focal works in the Mackintoshes' specially designed Scottish Room at the Eighth Vienna Secession Exhibition between 3 November and 27 December 1900 in Austria.

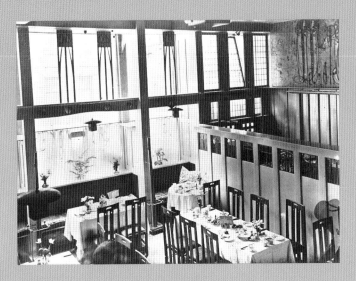

Upon their return to Glasgow both panels were installed in the white-painted Ladies' Luncheon Room in early 1901. Facing each other across the dining room – the corner of Mackintosh's *The Wassail* can be seen here – they became the colourful figurative focal points for the first tearoom interior scheme fully designed by Mackintosh for tearoom entrepreneur Miss Cranston.

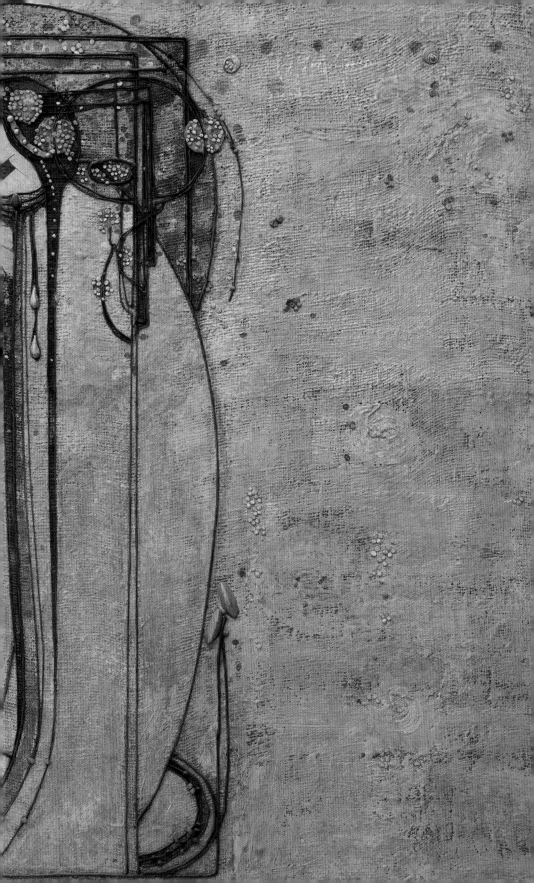

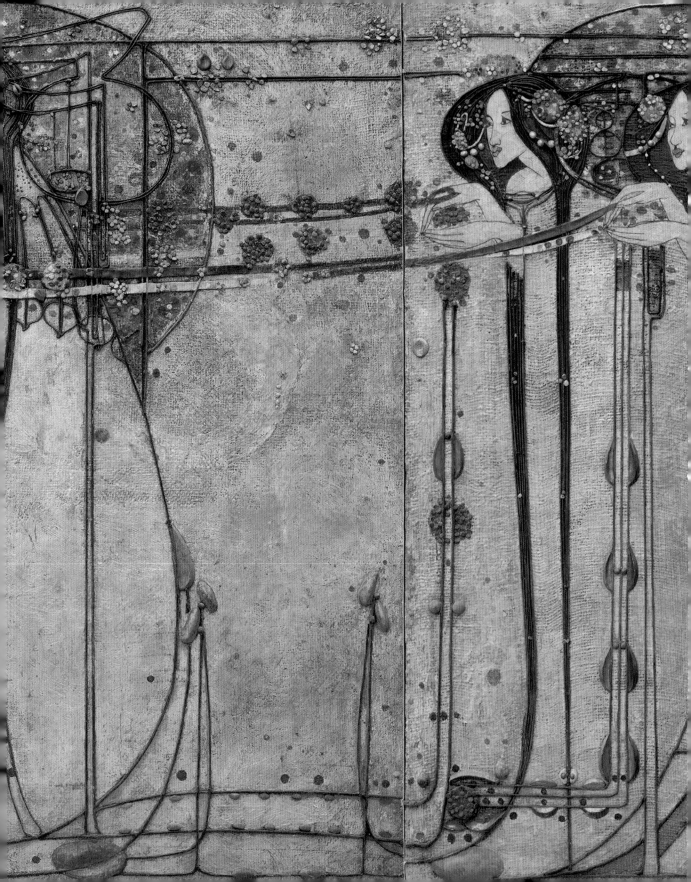

James Salmon Junior and John Gaff Gillespie

THE OTHER GLASGOW ART NOUVEAU ARCHITECTS

'One method which I have not seen done, but which would be most interesting to work out, is to use nothing but steel... building the walls as a steel ship is built...'

James Salmon Jnr,
lecture to the Glasgow Institute of Architects, 1908

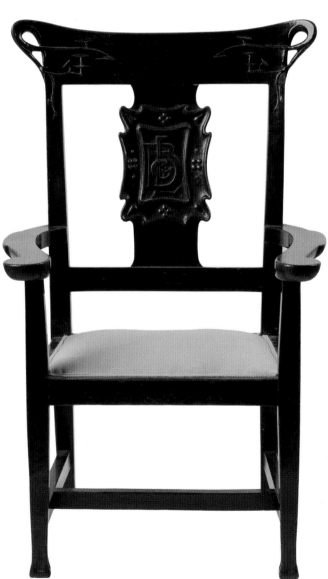

Mackintosh was not the only young architect with innovative ideas in Glasgow at this time. From the late 1890s, James Salmon (Junior) – who was following his father and grandfather into the architectural profession – and John Gaff Gillespie were forging a new architectural and decorative language along European Art Nouveau lines. At Salmon & Son architects they created commercial premises, civic amenities and private homes. Their most public New Art buildings were banks, more than ten of which were built between 1895 and 1906. Characteristic decoration included elaborate roofs with bird-topped finials, fine ironwork and stone carving of figurative and stylized plant forms.

Their masterpieces are two remarkable turn-of-the-century feats of engineering. 'The Hat Rack' (the St Vincent Street Chambers) is a steel-structured, expansive-windowed tour de force; its colloquial name irreverently equating the highly sculpted, undulating stone facade and spiky detailing with a piece of hall furniture. Salmon and Gillespie's last major commission was The Lion Chambers, an eight-storey building with a restricted footprint: a pioneering example of building with reinforced concrete. Innovative structural engineering enabled its modern clean look and many windows.

Facing Page:
Armchair from the Agents' Office, the British Linen Company (later Bank), Hutchesontown, Glasgow, 1899–1900
Designed by James Salmon Junior; maker unknown; carving possibly by John Crawford
Ebonized, carved oak, modern upholstery
Bought by Glasgow Museums with grant assistance from the National Fund for Acquisitions and the Friends of Glasgow Museums, 2015
E.2015.11.1

Finely carved plant tendrils curl back upon themselves to form the top back rail of this chair, evoking feelings of the Spook School. This fine, spiky and slightly unsettling detail is typical of Salmon's contribution to Glasgow Style decorative forms. The British Linen Company's initials 'BL & Co.' formed an integral part of Salmon's interior design for the Agents' Office. The monogram appears carved onto the chair backs, pierced into table legs and stencilled around the upper walls.

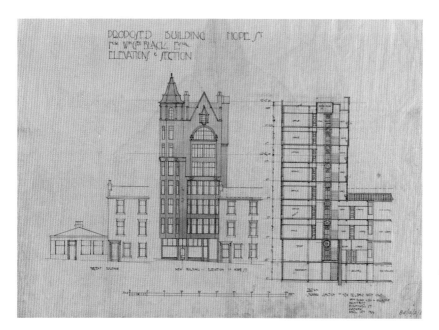

Elevation and section of The Lion Chambers, Hope Street, April 1904
Designed by James Salmon Junior and John Gaff Gillespie, Salmon, Son and Gillespie Architects; Structural Engineer: Louis Gustave Mouchel
Ink and wash on linen
Glasgow City Archives B4/12/2/806-7

This drawing shows Salmon and Gillespie's innovative new eight-storey building towering over the existing architecture in central Glasgow. Salmon, like his friend Mackintosh, took ideas for his new streamlined modern buildings from the study of Scottish architecture. The simple but robust forms of Scottish roughcast castles provide the underlying characteristics for this design. Salmon exaggerated and reinterpreted these characteristics for the twentieth century, making the most of the opportunities that new building materials and methods brought.

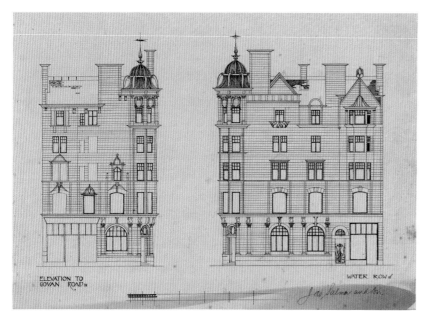

Elevations for the British Linen Company, Govan Cross branch, 1897
Designed and drawn by John Gaff Gillespie, Salmon and Son Architects
Ink on linen
Glasgow City Archives TD1309/G/2-1

A typical feature of Glasgow tenement design is the integration of commercial premises into the ground floor of the properties. The corner entrance of the Linen Bank at Govan Cross directs grandeur up through the corner flats to the elaborate cupola roof. The stonework is highly stylized around the windows and doors, mixing classical columns and figures with undulating organic decorative line. A number of talented sculptors, including Francis Derwent Wood, Johan Keller and Albert Hodge, carried out the stone carving for the practice.

The Importance
of Books

In the late nineteenth century, ideas were disseminated through books, journals and magazines. Books' attractive cover decoration helped to sell their contents. Journals employed photographic reproduction, while works of fiction relied on the illustrator's imagination to bring the author's words alive.

Two figures key in the application of Glasgow Style ideas to the printed word, and for spreading its visibility around the world, were Talwin Morris and Jessie Marion King. Both were members of the broader circle that visited the Macdonald sisters' studio, but their styles were contrasting. Morris, referred to by *The Studio* magazine as the fifth member of The Four, applied a Spook School poster minimalism to his book covers, while King worked in a vivacious figurative style, her detailed illustrations reading like a rapid outpouring of ideas.

Early works by both Morris and King indicate how much they also admired and drew from the work of Aubrey Beardsley.

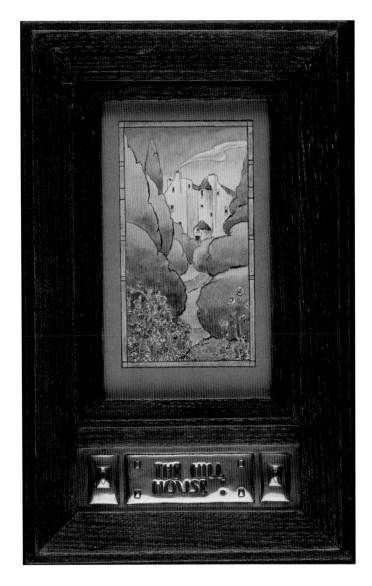

The Hill House, about 1905–11
Executed whilst residing at Dunglass, Bowling, Dunbartonshire
Talwin Morris
Stained wood, repoussé brass, glass, pencil, ink and watercolour on paper
Given by Walter W. Blackie, 1944
E.1944.4.b

Morris was appointed Art Director for Blackie & Son, Glasgow, in 1893. It was he who introduced his employer, publisher Walter Blackie, to his friend Charles Rennie Mackintosh, resulting in the commission of The Hill House in Helensburgh. Morris may have made this watercolour – depicting the house as a castellated vision from its deep gardens – and frame for his employer as a housewarming present.

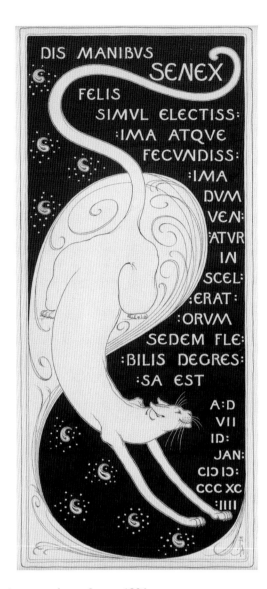

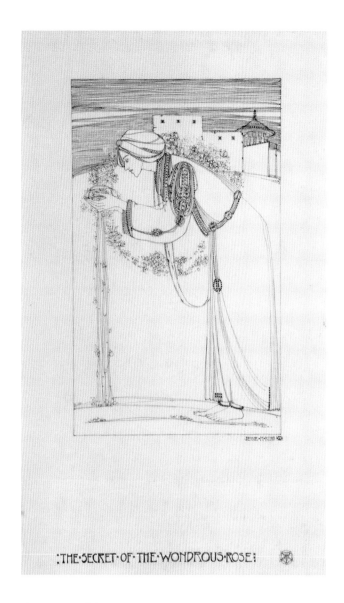

In memoriam – Senex, 1894
Talwin Morris
Ink on paper, stained wood, card
Given by Mrs Alice Talwin Morris, 1946
PR.1977.13.s (drawing), E.1946.5.n (frame)

Morris was such an admirer of Beardsley that he
even had a print by him on his wall – *The Kiss of
Judas*, which was published in *The Pall Mall Gazette*
in 1893. It was set in a picture frame of Morris's
own design and making – always dark stained wood
with repoussé metal and glass embellishments.
Other artists Morris similarly framed included
Finnish Symbolist painter Magnus Enckell, and
illustrator, writer (and later Suffrage campaigner)
Laurence Housman. It is very possible that Morris,
whilst working in London between 1891 and 1893,
was moving in the same circles as Beardsley and
Housman. All were forging distinctive new styles.

The Secret of the Wondrous Rose, undated, about 1894–96
Jessie Marion King
Pen and ink on paper
Bought by Glasgow Museums with the support of the Heritage
Lottery Fund, 2004
E.2005.1.54

This early drawing uses Beardsley's *Salomé* of 1893 as a
compositional starting point. King, like Mackintosh in his poster
design for the Glasgow Institute of Fine Art, makes the scene
less threatening. She turns the head of John the Baptist into a
flower, and the column of dripping blood into plant stems. Her
linear treatment of the brooding sky is identical to Mackintosh's
architectural perspective drawings of 1896. The date of this
drawing can only be guessed at. We should ask who influenced
whom?

Publications, Glasgow Style

Talwin Morris for Blackie & Son

Blackie & Son, Glasgow, was a major publisher of educational and scientific titles, fiction and biography. As Art Director, Morris established a clear brand identity using the new minimalist lines of the Glasgow Style. He tailored designs and manufacturing to suit the intended market and price band. The Gresham Publishing Company was created by Blackie in 1898 as an independent subsidiary for luxuriously produced volumes available by subscription. Some of Morris's most elaborately designed covers were produced for Gresham.

The underlying composition of these Gresham covers is identical – a large heart is outlined by sweeping curves created within the design by the lines of the main motifs. These motifs infer the subject within the books' pages – roses cry and hearts bleed over the death of a beloved monarch, whilst a pair of golden peacocks reference the modern aesthetic home. Just as every line and motif had a meaning and reason in the symbolic work of The Four, so it was in Morris's work.

The grooved patterns on these books are created by a process called debossing. Inked metal printing plates sink into the cloth-covered boards with the application of heavy pressure. Separate plates are made for each colour and title the design requires.

The Book of the Home: a practical guide to household management, Vol. 2, **1900**
Printed and debossed cloth hardcover, gilt
Bought by the Mitchell Library, 1900
Special Collections, The Mitchell Library 206030 640DAV

Queen Victoria: her life and reign: Vol. 1, **1901**
Printed and debossed cloth hardcover, gilt
Given by Dr William Glen to the Mitchell Library, 1959
Special Collections, The Mitchell Library 765075 RBC1383

Book cover design at The Glasgow School of Art

Bookbinding – book cover design – was one of the first five subjects taught following the establishment of the Technical Art Studios at The Glasgow School of Art in 1893. The first design instructor was Headmaster Fra Newbery, with visiting tuition by James Maclehose whose family were well-established publishers and printers working in Glasgow. Subjects taught included 'design to fill given spaces' and 'foliage from nature'.

Album von Dresden und Sächsische Schweiz, 1899
Cover designed by Jessie Marion King, 1898-99; published by Globus Verlag, Berlin, 1899
Printed ink on paper
Bought by Glasgow Museums with assistance from the National Fund for Acquisitions and the Friends of Glasgow Museums, 2018
GML.2018.4.47

This, King's second figurative cover for Globus Verlag, features a symmetrical, one could say almost religious, frieze of female figures. Six kneel with offerings of flowering hearts to the central standing figure wrapped with flowering garlands. Comparisons between this design have to be drawn with Margaret Macdonald's gesso of 1900, *The May Queen.*

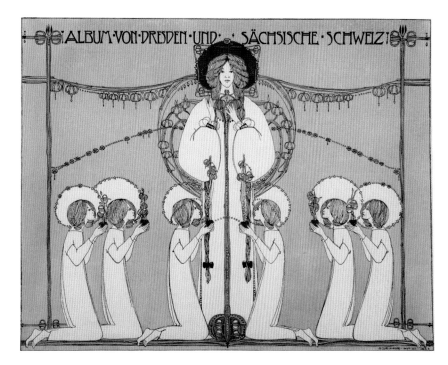

Jessie Marion King's designs for Globus Verlag

Jessie Marion King would become the most prolific book designer and illustrator of the Glasgow Style designers. Her big break came in 1898 when a German department store owner wrote to The Glasgow School of Art asking for an artist working in Glasgow's new style to design for his new publishing business. Francis Newbery recommended final-year student Jessie, then only 23. She produced both figurative and plant-form designs for the company. These early publications were souvenir photographic albums of Germany, wrapped in King's Glasgow Style cover.

Tail-piece, *The High History of the Holy Graal,* 1902–03
Jessie Marion King; published by Dent and Dutton, London and New York, 1903
Ink on vellum
Bought by Glasgow Museums with the support of the Heritage Lottery Fund, 2004
E.2005.1.61.1-3

From 1900 the Technical course at the Art School evolved into Bookcover Design and Decoration. King took on the role of design instructor, thus disseminating her influential stylistic ideas to her students. Design for books was not confined to the cover. An artist could also be asked to provide end papers, illustrative plates and internal page decorations. *The High History of the Holy Graal* was published in many editions; Jessie provided all the internal page decorations, such as this tail-piece, and the main cover of a gallant knight and his lady. A limited edition, with an opulent tooled and inked vellum cover set with mother-of-pearl, was also produced.

Talwin Morris

SOME PERSONAL DESIGNS AND JOTTINGS

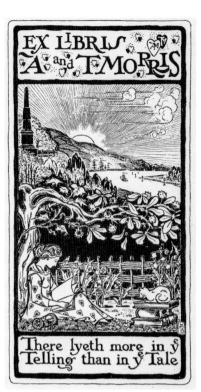

Ex Libris: There Lyeth more in ye Telling than in ye Tale, bookplate, 1893
Designed by Talwin Morris
Woodblock printed ink on paper (printing proof)
Given by Mrs Alice Talwin Morris, 1946
PR.1977.13.y

Morris had married his distant cousin, Alice Marsh, in 1892 in Surrey. In 1893 the couple made their home at Dunglass House on the site of the fourteenth-century Dunglass Castle in Bowling, on the edge of the River Clyde in Dunbartonshire. Alice was a children's writer and illustrator, and this bookplate full of love hearts, an evocation of their loving relationship, records their new residency. The obelisk is the monument to engineer Henry Bell adjacent to their new home.

Talwin and Alice Morris's Christmas card, 1897
Talwin Morris
Stencilled paint on card
Given by Mrs Alice Talwin Morris, 1946
PR.1977.13.x

The hooded figure bears similarity to Mackintosh's human–plant hybrid in the *Scottish Musical Review* poster of 1896. Morris finishes the card with what had by this time become his customary shorthand signature of two dots – space, one dot. Morse code? Or had he seen *tsuba* – Japanese sword guards – displayed in the Industrial Museum in Glasgow?

Sketchbook belonging to Talwin Morris, 1895
Executed whilst residing at Dunglass, Bowling, Dunbartonshire, 1895
Ink, watercolour and pencil on paper, linen hardcover
Given by Mrs Alice Talwin Morris, 1946
PR.1977.13.ac

A sketchbook is an artist's diary of things that catch the eye or come into the mind. This sketchbook was filled over a busy one-year period whilst Morris was living and working in Scotland. The pages show him exploring ideas, playing with fantastical plant forms, seeds and botanical study. He occasionally refers back to treatises on historic ornament, always careful to reference his source material.

Jessie Marion King

A PROLIFIC, COMMERCIALLY SUCCESSFUL, ILLUSTRATOR

Books were not the only medium using illustration to enhance content and visibility. All manner of commercial printed matter employed drawings, either coloured or black and white. Popular applications included advertising, bookplates, postcards, menu cards and greetings cards. Jessie Marion King worked across all these media, both commercially and for private enjoyment.

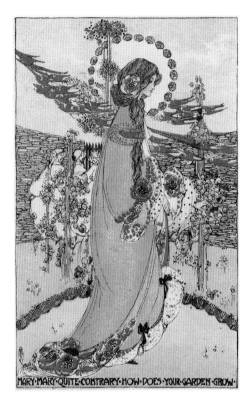

Mary, Mary, 1903
Postcard designed by Jessie Marion King; first published by Miller and Lang, Glasgow, 1903
Printed ink on satin, card, pen and ink
Bought by Glasgow Museums with the support of the Heritage Lottery Fund, 2004
E.2005.1.125.6

This is one of six designs that King made for a set of nursery rhyme postcards. Central to King's designs were her long-haired maidens. Their heads were haloed by a star-edged nimbus (she said she could see people's auras) and roses cascaded down their long gowns. Movement is added in this design through sweeping, swooping lines of a flock of birds.

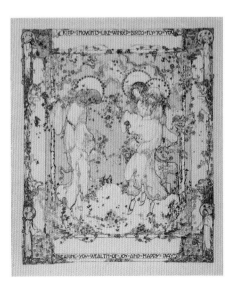

Kind Thoughts like Winged Birds..., greetings card, about 1906–10
Designed by Jessie Marion King
Ink and metallic ink on vellum
Bought by Glasgow Museums with the support of the Heritage Lottery Fund, 2004
E.2005.1.67

King produced several opulently illuminated greetings cards in the later 1900s, characterized by encrusted borders, minute detail, and metallic inks. This design is possibly her most vivacious, the wishes of joy and happiness expressed though dancing figures.

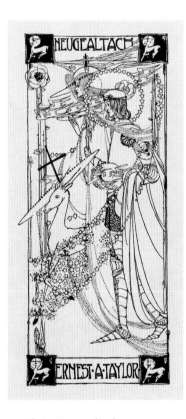

Ex Libris: Neugealtach [chivalrous], about 1905–10
Printed paper bookplate designed by Jessie M King for her husband-to-be Ernest Archibald Taylor
Bought by Glasgow Museums with the support of the Heritage Lottery Fund, 2004
E.2005.1.92

1893–1905:
TECHNICAL ART INSTRUCTION AND EXHIBITIONS

During this period the building blocks are put in place for art instruction to be seen as fundamental to education, and rolled out to all school pupils following a series of reports and Acts from 1882. Artistic Needlework becomes the first technical subject taught at The Glasgow School of Art, in 1892.

Simultaneously an important forum for female artists is founded, The Lady Artists' Club. From 1882 it holds monthly meetings, lectures, life drawing classes and an annual exhibition. It is so successful that it moves into ever bigger accommodation, and in 1893 moves again to No. 5 Blythswood Square, its home until 1970.

1893: Opening of the first Technical Art Studios. These operate out of dark, modified rooms adapted for use within the Corporation Galleries where the School of Art is then based. The first subjects taught are Stained Glass, Needlework, Bookbinding, Painting on China and Earthenware and Metalwork. The range of subjects taught expands over subsequent years.

1898, January 22: The People's Palace and Winter Gardens – the new civic East End branch museum – opens on Glasgow Green, adjacent to Templeton's carpet factory. Annual themed exhibitions are presented on craft, handiwork and applied design.

1899: New well-equipped Technical Art Studios are housed outside the School. Additional subjects taught include interior decoration, mosaics, sgraffito and gesso and lithographic design including posters.

1899–1907: The first phase of The Glasgow School of Art, with the temporary Technical Art Studios to the right.

1899, 20 December: Mackintosh's new Glasgow School of Art building is officially opened.

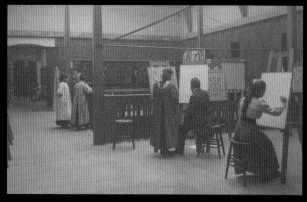

About 1900: Drawing from the Antique being taught in The Glasgow School of Art's new museum.

1900, December: 'Haus eines Kunst-Freundes', or House for an Art Lover, Ideas Competition is announced in the German publication *Zeitschrift für Innedekoration*. Mackintosh's designs are published as a portfolio of prints in 1902.

1901, May 2: The second Glasgow International Exhibition opens in Kelvingrove Park on 2 May, receiving over 11.5 million visitors in 6 months.

1901: Mackintosh designs four exhibition stands for the 1901 Exhibition – for Rae Brothers camera equipment; Francis Smith cabinetmaker; The Glasgow School of Art's bookbinding displays and the lace-making demonstration stand of department store Pettigrew & Stephens.

1901: Technical work by staff and students of The Glasgow School of Art is exhibited in educational pavilions within Kelvingrove. Work by many of the Glasgow Girls (Jessie M King, Jessie Newbery, Ann Macbeth, Marion and Margaret Wilson) is included.

1901: Glasgow cabinetmakers Wylie and Lochhead launch their New Art Glasgow Style interiors in their Industrial Hall pavilion. The interiors are the work of three designers: John Ednie, George Logan and Ernest Archibald Taylor.

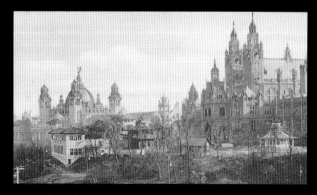

1901: The golden-domed industrial hall of the Glasgow International Exhibition and the new Municipal Galleries; Kelvingrove.

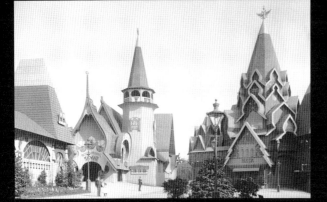

1901, mid-June: The fantastical pavilions of the large Russian Village designed by Art Nouveau architect Fyodor Shekhtel, formally open at the Exhibition. Painted pale green, red, salmon and blue with gilding and silvering, the buildings both delight and infuriate local taste; described by some as 'Glasgow School'.

1901: The School of Art starts teacher training classes, assisting the new system of drawing instruction being slowly – and until 1907 voluntarily – adopted in schools. These are formalized into a Public School Teacher's Drawing Diploma in 1903.

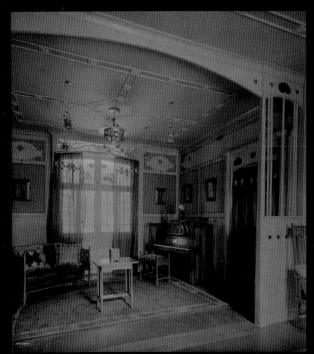

1901: EA Taylor's drawing room in Wylie & Lochhead's Exhibition pavilion.

1902: Works by The Glasgow School of Art and other Glasgow makers, including George Walton and Wylie & Lochhead, are included in the exhibition *British Arts & Crafts* at the National Museum of Art in Budapest, Hungary. Newbery organizes the selection, largely taken from the Glasgow 1901 exhibition.

1902: Newbery selects and Mackintosh designs the Scottish Section pavilion at the International Exhibition of Modern Decorative Art in Turin, Italy. There are three rooms: The Rose Boudoir by the Mackintoshes, A Lady's Writing Room by the McNairs, and a third space displaying work by some 50 designers and makers associated with The Glasgow School of Art.

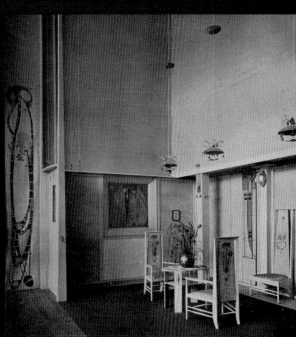

1902: The Rose Boudoir in the International Exhibition of Modern Decorative Art in Turin, Italy.

1902, June: Construction starts on Mackintosh's design for a music room for businessman Fritz Waerndorfer's Vienna home.

1902, 22 December: Mackintosh displays a room setting with furniture and artwork at the first New Art exhibition in Russia, *Architecture and Design of the New Style* in Moscow.

1905: Teacher training in art at The Glasgow School of Art continues to respond to changes in the schools' curriculum. The first higher-grade teaching qualification in technical subjects offered is a 2-year certificate programme in Art Needlework under Ann Macbeth's supervision.

1905, 21 December: The new building for the Glasgow and West of Scotland Technical College (est.1882) formally opens on George Street. Fra Newbery continues to have close ties with technical instruction there, frequently advising.

Design and Making

GLASGOW'S TECHNICAL CRAFTS

'The influence of the Mackintosh group is far-reaching. Its influence in its native city is already so generally obvious that Mackintosh's repertoire of forms may almost be said to have created a local style.'

Hermann Muthesius, Das Englische Haus, 1904

The rise of the Glasgow Style goes hand-in-hand with the founding of the Technical Art Studios at The Glasgow School of Art (GSA), made possible through a Government Act of 1890 redirecting tax on alcohol to investment in Britain's technical and manual instruction classes. The aim was to create a skilled workforce, raise the standards of design and improve product for the international export market.

When the Studios were established, the Art School had long been ensconced in rented rooms attached to the Corporation Art Galleries on Sauchiehall Street – a good location for students to study the City's growing art collection and special

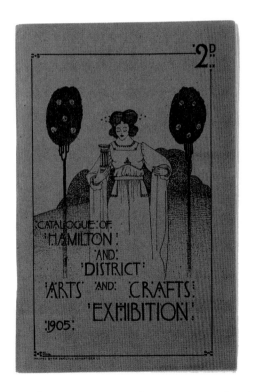

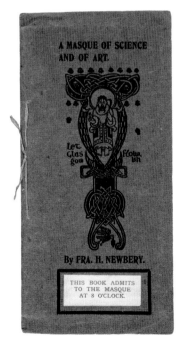

Programme for the Masque of Science and Art, 21 December 1905
Written by Francis H. Newbery; illustrated by D. Broadfoot Carter
Printed sugar paper and paper, ribbon
Bought by Glasgow Museums with the support of the Heritage Lottery Fund, 2004
E.2005.1.110

Produced by Fra Newbery and performed by staff and students of the GSA, this event marked the formal opening of the new Glasgow and West of Scotland Technical College. It celebrated the links between the two institutions: Science and Art.

Catalogue, Hamilton and District Arts and Crafts Exhibition, 1905
Cover illustration by William Hume
Printed sugar paper and paper
Bought by Glasgow Museums, 2015
E.2015.12.1

The GSA provided an outreach role, promoting design skills in many ways. This exhibition, which featured work by local tradesmen, was organized with advice from Fra Newbery and other staff.

exhibitions, but not for suitable studio and workshop space, especially for technical instruction. By the mid-1880s, both institutions – the Art School and the Art Galleries – had decided larger bespoke buildings were required to meet their respective expansion needs.

As the Art School moved into Mackintosh's purpose-built new premises, so the facilities and equipment grew, expanding the instruction provided. Between 1899 and 1907 the Studios were based in a long, single storey corrugated iron-roofed shed to the right of Mackintosh's new School. Rooms were allocated for the teaching of metalwork, leaded-glass, pottery, wood and stone carving and decoration and design.

Shaping this important development was headmaster Francis (Fra) Newbery, who forged a high-profile creative hub linking students directly with practitioners and industry. These Studios effectively established a Glasgow Arts and Crafts Movement. Newbery was a connector of people. He clearly enjoyed creating social events, be they pageants or masques, Art Club meetings or exhibitions. As the Head of the GSA his participation at so many events meant he was a constant networker. He tirelessly served on committees and boards across the country, and always took the opportunity to improve the School's output and create new educational opportunities. He was good at talent spotting and forging new dynamics between creatives, manufacturers and philanthropists and educational institutions to make things happen.

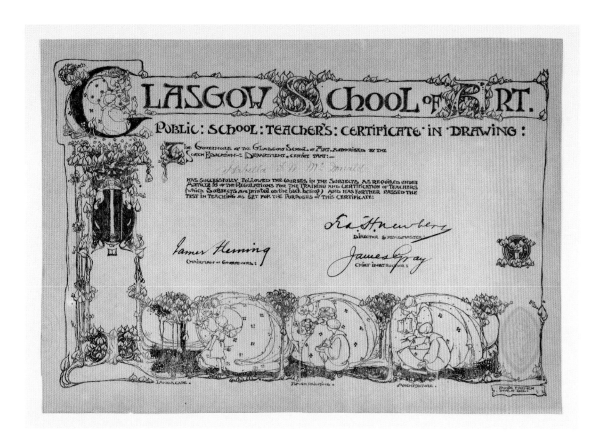

Public School Teacher's Certificate in Drawing, 1905–06
Designed by Annie French
Printed paper and ink
E.2007.4

A new teaching qualification was created in 1906 following changes made by the Scotch (sic) Education Department to the way teacher training was organized in Scotland. French's certificate design represents key subjects in art education through a female teacher tutoring a child. Modelling is in the big G; along the bottom Drawing from landscape; flower painting (Nature Study) and Architecture.

Teaching Design and Decoration

INDUSTRIAL APPLICATION AND ARTS AND CRAFTS

The Technical Art Studios taught both design and practical work using materials and tools. All subjects had an industrial application or would enable students to set up their own businesses and workshops. 'Painting on China and Earthenware' – later 'Ceramic Decoration, Design and Painting' – was one of the first subjects taught, in 1893, by James Fleming of the Britannia Pottery. Tuition was given in painting, modelling, design and application, materials, colours, processes, glazes and firing.

The hand-painted decoration of industrial ceramics

These cups and saucers show how design applied as decoration can transform the same object. The Scottish landscapes on the pink cup and saucer are by an unknown Victorian hand working at Glasgow's Bell's Pottery. The butterfly and flower design on the other set is by Helen Walton, the lead instructor of applied ceramic decoration at the GSA from 1893 and who, with her younger sister Hannah, ran a teaching studio in Hillhead painting onto both glass and ceramic blanks.

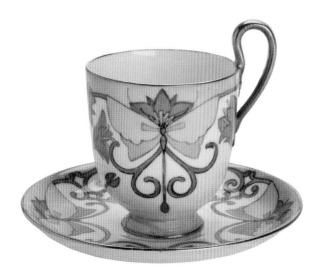

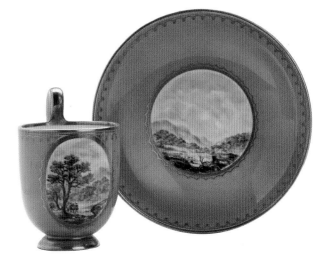

Cup and saucer, about 1906
Hand-painted by Helen Walton; ceramic blanks manufactured by Bell's Pottery, Glasgow
Hand-painted bone china, glaze, gilt
E.1984.29.9 and E.1984.29.10

Cup and saucer, late 19th century
Bell's Pottery, Glasgow
Hand-painted bone china, glaze, gilt
Given by Miss A. Fleming (JA Fleming Collection), 1938
E.1938.10.aa.1 and E.1938.10.af.2

EXAMPLES FROM THE ARTS AND CRAFTS STUDIOS OF GSA GRADUATES

Salver decorated with Celtic knotwork (detail), 1901
Designed and made by Alexander Ritchie, 1900–01
Repoussé copper
Given by Mr Murdo MacDonald, 2006
E.2007.3.14

Alexander Ritchie and his wife Euphemia met when students at the GSA. In June 1900 Ritchie was appointed custodian of Iona Abbey. There he and Euphemia produced and sold souvenir metalwork, wood carving and textiles in the Celtic Revival style using motifs and knotted borders derived from the 6th- to 15th-century stone carvings and excavation finds on the island. The ship on this salver is taken from an eleventh-century Viking stone.

Glass goblet with applied rose decoration, about 1898–1900
Made by James Rankeen Garrow; possibly designed by James Herbert McNair
Lamp-blown glass
From the collections of the Victoria & Albert Museum. Gift of Dr RJS Garrow.
CIRC.580-1954

Chemist and scientific glassblower James Rankeen Garrow was interested by the material possibilities of blowing hot glass at his workshop bench, a technique called lampworking. Examples of his studio glass were exhibited at the 1898 Arts and Crafts exhibition, some with the design attribution of McNair.

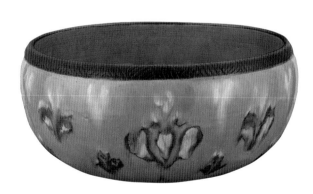

Bowl with glazed iris decoration, 1907
Designed and made by Hugh Allan, Allander Pottery, Milngavie
Earthenware, glaze
Acquired by Glasgow Museums, 1964
E.1964.3.h

Plate with glazed peacock feather decoration, 1904
Hand-glazed, and possibly made, by Jessie R. Allan; made at the Allander Pottery, Milngavie
Earthenware, glaze
Bought by Glasgow Museums, 1988
E.1988.36

Hugh Allan, Mackintosh's contemporary at the GSA, established the first studio pottery in Scotland in 1904. He and chemist Robert McLaurin created glazes inspired by Oriental ceramics. Allan's sister Jessie, a skilled painter, was the first woman to teach at the GSA. Some pieces of Allander pottery have her signature, indicating that she assisted her brother with ideas.

Teaching Design and Decoration

NEEDLEWORK

'The hand that holds the needle beautifies the world'

Francis Newbery, 1902

This quotation comes from Fra Newbery's written appreciation of Ann Macbeth's needlework, which was published in *The Studio* magazine in 1902. In it he praised the value of art applied to the everyday, and criticized philosopher Adam Smith for failing to classify the spiritual wealth of the handmade, such as 'the towel upon which we dry our hands'.

Needlework was the first technical subject introduced at The Glasgow School of Art, taught by Miss Dunlop in 1892. The Needlework Department took on a new energy in 1894, under the leadership of Newbury's talented wife, Jessie. Her designs and teaching methods had a profound effect on the development of the Glasgow Style and the department received international acclaim, both staff and students exhibiting their work widely. In 1901, Macbeth was appointed Newbery's assistant instructress and both women exhibited an impressive range of work at the Glasgow International Exhibition that year. Macbeth took full control of needlework instruction from 1908 and led the department forward to even greater educational

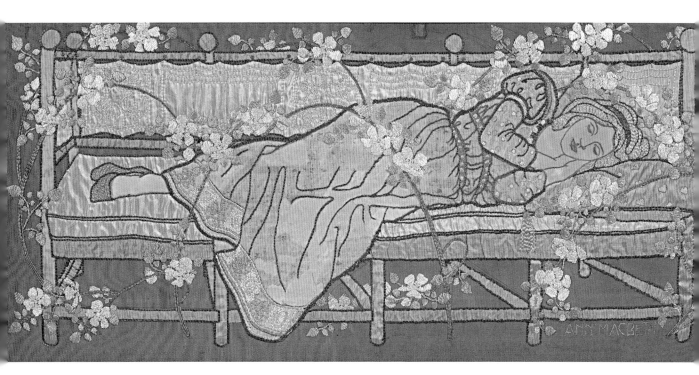

The Sleeping Beauty, about 1899–1900
Designed and worked by Ann Macbeth
Embroidered and appliqued linen, silk, gold thread
Bought by Glasgow Museums, 1989
E.1989.9

Embroidered using satin, stem and knot stitches with French knots and couching, this silk appliqué panel was created by Macbeth whilst still a student in Jessie Newbery's needlework and embroidery department at the GSA.

Embroidered drawstring bag, about 1902–03
Designed and worked by Ellison J. Young
Linen, silk
Given by the artist's family, 1980
E.1980.169.5

Young was a prize-winning student at the GSA and this design shows why. It demonstrates a clever absorption of Glasgow Style composition and flower study, in this case snowdrops. She gained her Certificate for Art Needlework in 1908.

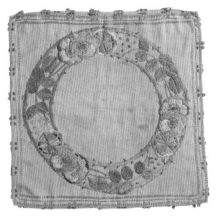

Embroidered cushion cover, about 1899–1900
Designed and made by Ann Macbeth
Linen, silk, glass
Given by Mary Newbery Sturrock, 1953
E.1953.53.d

Each Glasgow Style designer had their preferred way to depict a rose, the floral motif of the Glasgow Style. Macbeth favoured the tea rose, in full bloom with stamens visible. Here she orders the blooms, leaves and thorned stems into a circular design, flipping one flower head so you see its back and the green starburst of the flower's sepals. The embroidery includes small pastel-coloured glass beads sewn into the design – a popular addition to Glasgow Style needlework.

**'Under Every Grief and Pine',
cushion cover, 1899–1900**
Designed and worked by Jessie Newbery
Linen, wool
Given to Glasgow Museums by Mary Newbery Sturrock, 1953
E.1953.53.c

Newbery is credited for conceiving the Glasgow Style lettering. She often sewed poetry into her needlework – this cushion quotes from William Blake's *Auguries of Innocence*, published in 1863. The exaggerated lettering style for her needlework drew inspiration from seventeenth-century Scottish tombstones and plaques. Letters were elongated vertically, horizontal crossbars extended so they capped or underlined neighbouring letters. But she retained some Roman forms, such as the V-shaped U, to acknowledge and express a timeless age.

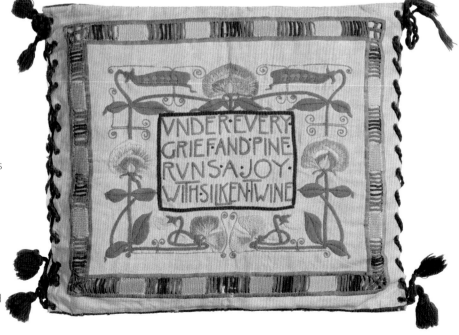

Teaching Design and Decoration

METALWORK

Metalwork – in silver, brass, copper and iron – was taught in the Technical Art Studios from 1893, two afternoons and three evenings weekly. Students learnt how to draw, design and model both ornament and the figure; about materials, tools and the techniques of repoussé, chasing and engraving. Enamels and precious metals were added to the syllabus from the early 1900s. The first technical instructor was sculptor Kellock Brown, followed by silversmith Peter Wylie Davidson from 1897.

Peter Wylie Davidson had been a student alongside Mackintosh at the GSA. He went on to be the longest serving instructor from the Glasgow Style era, finally retiring from teaching in 1935. Davidson taught metalsmithing techniques alongside many talented design instructors, including John Guthrie, Dorothy Carleton Smyth, Ann Macbeth and Frances McNair. The department gained international recognition for the quality of its work.

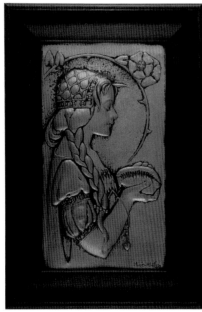

Decorative metal panel: Girl with Cowrie Shell, about 1900
Designed and made by Marion Henderson Wilson
Chased and repoussé white metal, stained wood
Bought by Glasgow Museums, 2007
E.2007.13

Henderson Wilson attended the GSA at the same time as Mackintosh. Here she achieves subtle modelling of the flesh by chasing and scratching the metal. She uses blackening when polishing to give the exaggerated depth.

Longcase clock: The Swallow's Flight, after 1902
Metalwork designed and made by Peter Wylie Davidson; frame possibly designed by Charles Rennie Mackintosh
Stained wood, chased and repoussé brass, cast copper, lead, metals, turquoise
Bought by Glasgow Museums with assistance from The Art Fund, the National Fund for Acquisitions, and the Friends of Glasgow Museums, 2011
E.2011.12

Davidson brings a living dynamism to this clock by use of selective metalworking techniques. Speeding around the clock face are 14 chased and repoussé swallows; the pair on the pendulum, cast in metal, zoom through a drawn wirework cloud.

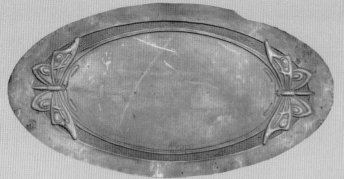

Unfinished chased and repoussé tray, about 1901–10
Designed and made by Margaret Gilmour
Chased and repoussé white metal, pencil
Given to Glasgow Museums, 1984
E.1984.112

Guiding pencil lines are visibly marked on this half-completed tray. Gilmour has worked the metal from front and back to create the raised design. This piece was probably discarded when the rim was unevenly cut.

Design for decorative metalwork, about 1906–14
John C. Hall & Co., Glasgow
Pencil on tracing paper
Given by the artist's family, 1987
E.1987.57.2

This is a working drawing, and the start of the embossing process using chasing and repoussé techniques. The back of this paper is covered with a thick layer of graphite to enable the design to be transferred onto a metal sheet beneath.

Decorative metal panel: Triptych, about 1900
Designed and made by Margaret Thomson Wilson
Chased and repoussé copper, stained wood
Private Collection

The plant forms unite the three panels; the rose heads are not classic Glasgow Style, but the ordering of the stems and leaves is. Used here is the technique of chasing – modelling the repoussé metal from the front to emphasize form.

Teaching Design and Making

FLOWER STUDY

All the technical subjects taught at the GSA involved lessons in the taming and shaping of the natural world for applied ornamental purpose. Art Botany was the term given to the study of plant forms, growth and construction for decorative purpose. Design reformer Christopher Dresser was an early instructor, publishing his treatise *Unity in Variety* in 1859. Specimens for study were initially provided by the City's Parks Department, but from 1909 the Glasgow School of Art had its own conservatory. Floral patterning and simplification, plant symbolism, and the ordering of the stages of plant growth are central to understanding the design philosophy informing the Glasgow Style.

Embroidered tea cosy, about 1910s
Designed and made by Mary Begg
Shot silk, floss silk thread
Given by the artist's family, 1980
E.1980.181.3

The flower embroidered here is a fuchsia, the heads of which usually hang as a disordered cascade. Begg tames and adapts the flowers and leaves to fill a difficult semi-circular space. It is a perfect example of plant study executed Glasgow Style.

Sea Pink, Holy Island, July 1901
Charles Rennie Mackintosh
Pencil and watercolour on paper
From the collections of The Hunterian, University of Glasgow
GLAHA 41004

Ixias, St Mary's, Scilly, 1904
Charles Rennie Mackintosh
Pencil and watercolour on paper
Given by James Meldrum, 1969
PR.1969.12.b

Mackintosh was masterful in capturing the essential forms and lines of plants and infusing these into his designs. These watercolour studies show some of his early methods of observation. In *Sea Pink* he annotated the stages of plant growth onto this early flower study: 'Bud', 'Flower' and 'Seed'. The shapes formed by the stems against the tuft of ground intrigued him; he blocked these out in the same way a stencil-card would be cut. In *Ixias* (above) he deliberately superimposed and overlapped the outlines of individual flower heads, buds and stems on top of each other to create a busy, lively composition.

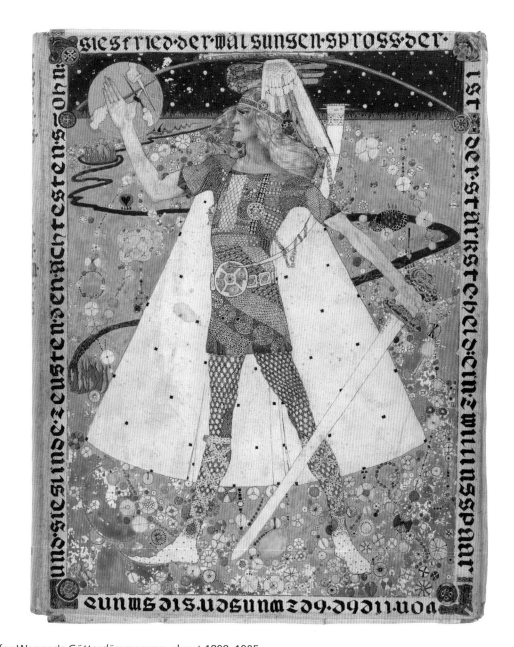

Book cover for Wagner's *Götterdämmerung*, about 1898–1905
Cover designed and made by Dorothy Carleton Smyth; printed score published by Schott & Co. about 1898
Printed paper, card, ink, paint
Given by the artist's family, 1943
E.1943.1

Smyth's cover for this score of 'The Twilight of the Gods' brilliantly communicates the epic drama of Wagner's fourth and last part of *The Ring Cycle*, his operatic interpretation of the Norse sagas. Key elements of the finale of the story are illustrated, framed within borders of German script and Celtic knotwork. The angular style of the calligraphy contrasts with the bright imaginary floral carpet of the landscape.

Smyth, like fellow GSA tutors Jessie M King and Annie French, delighted in encrusting the paper's surface with detail into her illustrative work. Smyth pays particular attention to the decorative patterns to be created by the chain-mail armour as it wraps around the body. She pursued a very successful career as a costume designer after 1906, working on Shakespearean productions in London and Stratford-upon-Avon, and opera and theatre in Paris and Stockholm.

Teaching Design and Decoration
STAINED GLASS AND MOSAIC

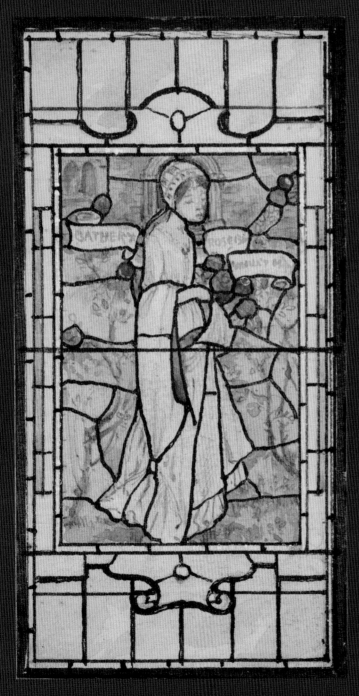

"The process of stained glass may be divided into two sections: the one which builds up a mosaic, the other which calls in painting to accentuate forms and define certain details.'

Oscar Paterson

Stained glass was first taught at the Technical Art Studios in 1893, two afternoons and three evenings weekly. Course instructors, visiting lecturers and examiners were some of the most accomplished Glasgow names designing for, and working in, the medium: Norman McDougall – who had trained with Daniel Cottier in London – Stephen Adam, J&W Guthrie, and later Stephen Adam Junior and William Meikle. It was a discipline and business that invited excellent opportunities for freelance design. Such designers included the Glasgow Boys painters David Gauld and Harrington Mann; and William Scott Morton, instructor in interior decoration at the School.

Design for leaded glass, *Gather Ye Rosebuds While Ye May*, about 1898–1901
J & W Guthrie and Andrew Wells Ltd, Glasgow
Pencil, ink and watercolour on paper and card
Acquired from Guthrie & Wells, 1979
PP.1979.128.108

Mosaic panel, *Gather Ye Rosebuds While Ye May*, about 1898–1910
Attributed to J & W Guthrie and Andrew Wells Ltd, Glasgow
Glazed frit, glass beads and cabochons, paint, grout, stained wood
Bought by Glasgow Museums with assistance from the National Fund for Acquisitions, 2010
E.2010.11.1

Stained glass and mosaic have an obvious design relationship; both are an arrangement of coloured fragments. The design shown here on the left is for a stained and leaded-glass window; the same pictorial image was turned into the mosaic panel on the right.

Mosaic was taught at the GSA from 1895; first by Jessie Newbery, then by John Guthrie when he was Director of the GSA's Department of Design between 1897 and 1903. Later tutors would include Robert Anning Bell. Guthrie's family business had long worked as interior decorators across all disciplines including leaded-glass and mosaic. Guthrie taught mosaic at the School of Art between 1897 and 1911.

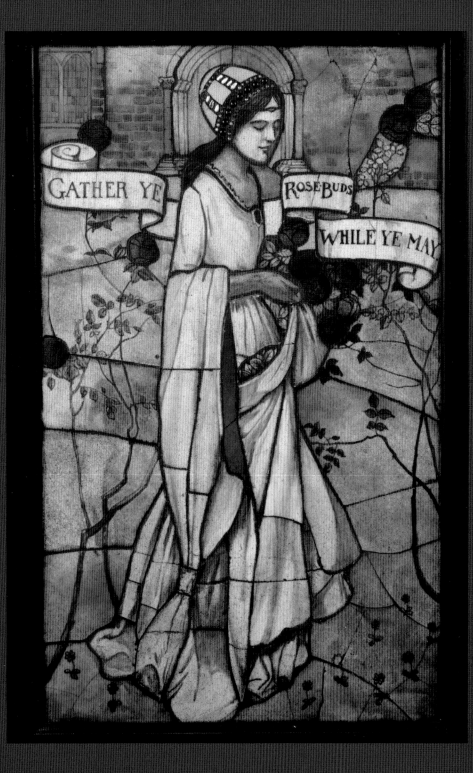

GATHER YE ROSE-BUDS WHILE YE MAY

Have a look around Glasgow and its suburbs: the late nineteenth- and early twentieth-century tenements, houses and commercial buildings will reveal the popularity then of leaded-glass for decoration.

Facing Page:
Leaded-glass panel: Water Sprite, about 1895–96
Designed by William Gibson Morton; probably made by William Stewart
Leaded coloured glass
Bought by Glasgow Museums with assistance from the National Fund for Acquisitions
PP.1981.29

The colours of the glass grab the attention. The lines of lead direct the rhythm. The glass is thoughtfully selected and cut so colour variations and textures 'paint' the picture's detail. Additional detail is minimal and applied as paint by brush.

Design for leaded glass: 'O Come Unto These Yellow Sands' (detail), about 1898
Oscar Paterson
Design for leaded glass, watercolour and pencil on paper
Bought by Glasgow Museums with assistance from the National Fund for Acquisitions, 1981
PP.1981.81.8.a–.f

These are the left-hand lights from a six-light window featuring one of Paterson's favourite themes – the title is taken from Shakespeare's *The Tempest* – and his 'distinctly novel colour-scheme' was described in *The Studio* thus: 'The harmony of colour is placed in a high key – lemon and white with neutral greys and actual black employed freely'.

Cartoon for a three-light window, early 1900s
John C. Hall & Co., Glasgow
Watercolour and ink on paper adhered to card
Given by the artist's family, 1978
PP.1978.99.18

John C Hall and Oscar Paterson set up their Glasgow studios at around the same time. Both created very distinctive sparse airy scenes using clear and textured glass and a restricted palette. Here Hall uses spots of colour to brilliant effect.

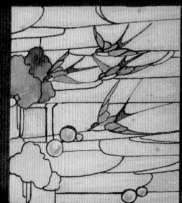

Teaching Design and Decoration
FURNITURE AND INTERIORS

Wood carving and applied design, taught from 1893, were the most pertinent subjects offered to furniture makers. Decoration of interiors was added in 1900, but furniture design was not taught until 1902, and then only for a few years as it did not naturally sit in the Technical Art Studios. The Glasgow & West of Scotland Technical College (GWSTC) was providing comprehensive tuition in cabinetmaking and house decoration, in its trades-feeding Industrial Arts Department. The three young designers responsible for the New Art interiors of cabinetmakers Wylie & Lochhead – Ernest Archibald Taylor, George Logan and John Ednie – were all influential instructors there after 1899.

Gesso fronted cabinet, 1906–07
Designed by Henry Taylor Wyse; made by the Scottish Guild for Handicraft; gesso doors made by Henry Taylor Wyse; cabinetmaker, William Middleton of Arbroath; metalwork possibly by John Adams
Stained oak, cedar and pine, painted gesso, metals
Bought by Glasgow Museums with assistance from the Art Fund and the National Fund for Acquisitions, 2009
E.2009.7

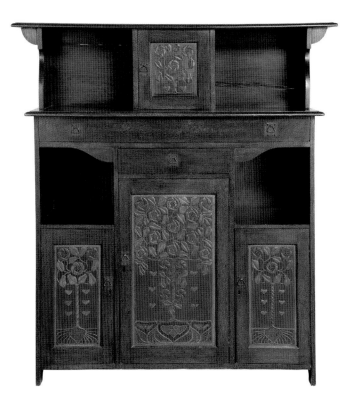

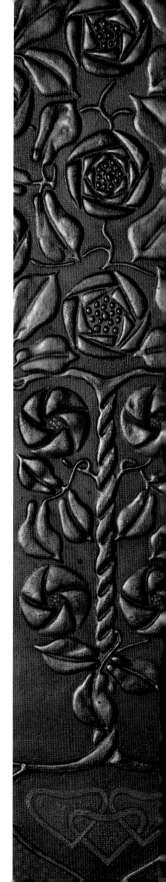

Gesso work – relief plaster sculpting – was taught at The Glasgow School of Art from 1900, and this cabinet shows one application for the technique. This high relief application of gesso appears to be crafted on the upper door using different techniques and materials to those on the lower doors.

Wyse self-published *Simple Furniture*, a catalogue of his 'simple and useful' furniture designs, in 1900. These were manufactured to order by the workshop of a local maker, William Middleton.

This is the only known furniture piece designed by Wyse utilizing such high relief gesso decoration, so we could conclude that this was an exhibition piece. It was on display at the Scottish Guild for Handicrafts Glasgow exhibition in 1907. Wyse was a leading member of the Guild, which he helped found in 1898. He was a multi-talented individual working as a teacher, educator, painter and fine craftsman across a wide variety of media in Dundee, Arbroath, Coatbridge and Edinburgh.

Fireplace and inglenook design, for a billiards room, 1902

John Ednie, commissioned for 26 Huntley Gardens, Kelvinside, Glasgow
Pen and watercolour on paper
Bought by Glasgow Museums with assistance from the National Fund for Acquisitions, 1982
E.1982.77.5

This sketch for a fully furnished Glasgow Style interior only hints at the richly applied Glasgow Style decoration Ednie planned for this interior. Roses and plant forms were applied to the design of leaded-glass windows, upholstery, stencilled walls and carved furniture. Ednie was a skilled interior designer and lectured in cabinet-making design. From 1906 he headed up the Industrial Arts Department at the Glasgow & West of Scotland Technical College. For the last six years of his life, between 1928 and 1934, he was the Principal of the School of Art in Cairo, Egypt.

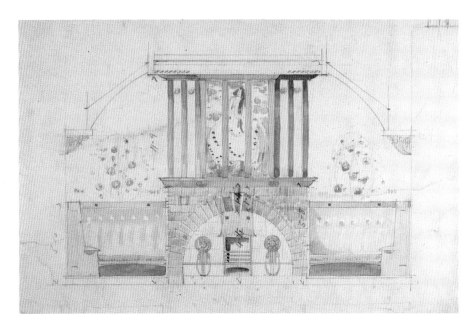

Sideboard and chair design, about 1903

Ernest Archibald Taylor
Pencil, ink and watercolour on paper
Bought by Glasgow Museums with assistance from the National Fund for Acquisitions, 1982
E.1982.77.2

Taylor's drawing room for leading cabinetmakers and upholsterers Wylie and Lochhead at the 1901 Exhibition followed Mackintosh's lead into the light and bright Glasgow Style interiors: white-painted wood; pastel stencils; mahogany and purple-stained furniture. Taylor taught furniture design at The Glasgow School of Art between 1902 and 1906, and at the Technical College between 1899 and 1906. This design drawing for a sideboard with leaded-glass rose panel also shows his construction detailings in the margins – profiles of mouldings, beading and layout options for mosaic tiling.

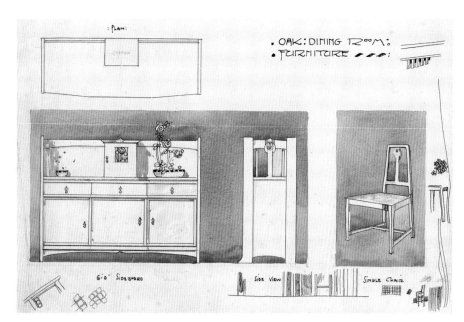

The Personalizing of Artistic Interiors

Left:

Stencilled hanging: blue flower, about 1900
Designed and made by Talwin Morris
Linen, paint
Given to Glasgow Museums by
Mrs Alice Talwin Morris, 1946
PR.1977.13.an

What survives from the decoration of Morris's home at Dunglass gives us an insight into his creative and quirky personality. He seems to have been an expert stenciller, creating a number of panels and curtains for the decoration of his own home. He made a series of these elegant wall-hangings featuring Egyptian flower forms in blue or yellow and his signature of three dots. The rectangular blocks of colour weight the design visually.

Right:

Sketch design for a sconce in wood and beaten metal, 1904
Pencil, watercolour, paper
Given to Glasgow Museums by
Mrs Alice Talwin Morris, 1946
PR.1977.13.v

This candle sconce was a commission by Walter Blackie for his new home, The Hill House in Helensburgh, Dunbartonshire. The sconce, now fitted with electric bulbs, still hangs in the hall there. The decorative metal panel was made in chased and repoussé brass pierced to accommodate inset glass cabochons for the peacock's tail. The green glass would be backed by an applied metal leaf to allow the colour of the glass to bounce back with the light falling upon it.

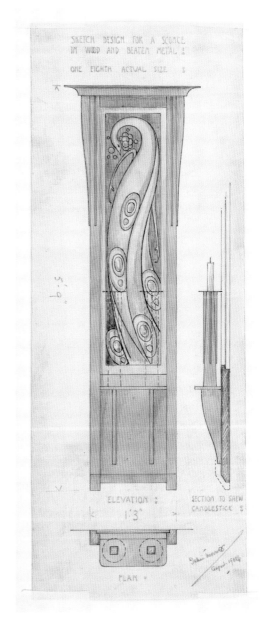

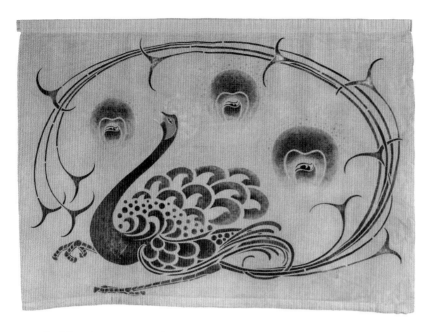
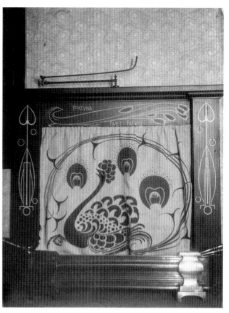

Stencilled fireplace curtain, about 1895–98
Designed and made by Talwin Morris
Linen, paint
Given by Mrs Alice Talwin Morris, 1946
PR.1977.13.al; photograph E.1946.5.y.16

This exuberant bird is one of two stencilled fireplace curtains that survive from Morris's home. The photograph on the right, from *The Studio* magazine, shows how it was part of a bigger decorative scheme, with peacock feather wallpaper and painted decoration on the stone fireplace. The whole design is rather Beardsley; something Gleeson White, editor of *The Studio*, remarked upon when he visited Dunglass in 1896–97.

Photographs of decorative metal fingerplates, 1896–97
Designed and made by Talwin Morris
Photograph on card
E.1946.5.y.9

Talwin Morris was definitely a cat person. This photograph shows three decorative metal fingerplates featuring elongated stylized Spook School cats that he made for his home in Dunglass, Bowling, Dunbartonshire. The centre fingerplate states 'Cave Felem', Latin for 'Beware of the Cat'. The right-hand lock plate shows a yawning – or mewling – cat, its open mouth serving as the keyhole. Morris clearly also had a great sense of humour!

The Artistic Interior

'All artists know that the pleasure derivable from their work is their life's pleasure — the very spirit and soul of their existence...'

Charles Rennie Mackintosh,
Lecture: Seemliness, 1902

The work bursting forth from these young Glasgow designers in the later 1890s captures their exuberance as they explored ideas, materials and techniques. These were exciting times: new friendships, success – and controversy – participation in exhibitions, features in publications, meeting different people; potential clients and commissions. This energetic joy of personal expression can be seen in their early Glasgow Style work, in designs made for others and for themselves. Furniture has presence and personality. Walls are stencilled with an abundance of stylized natural forms. Plain surfaces are inlaid with texture and colour. And there is humour.

Design for a bedroom, Westdel, Glasgow, about 1898
Charles Rennie Mackintosh; commissioned by publisher Robert Maclehose
Pencil and watercolour on wove paper
From the collections of The Hunterian, University of Glasgow
GLAHA 41106

This south wall elevation is part of Mackintosh's first white domestic interior with proposed integrated decorative scheme; white painted carved and pierced wood, a stencilled frieze of plant forms, embroidered curtains and a repoussé peacock panel above the stone and iron fireplace.

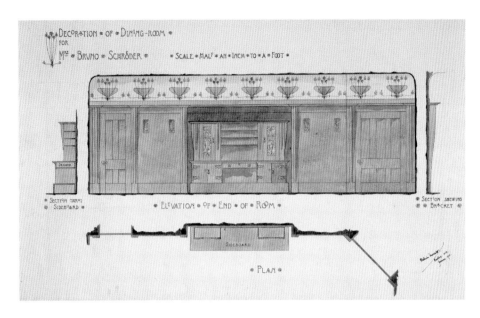

Decoration of dining room for Mrs Bruno Schroeder, 1901
Talwin Morris
Watercolour, ink, paper
Given by Mrs Alice Talwin Morris, 1946
PR.1977.13.q

Morris, a trained architect, was invited to design several interior schemes. His wood panelled rooms and furniture designs utilized the bold projecting corniced top favoured by the Glasgow Style designers. Morris softened the rigid angularity by using distinctive corbels with a taut tapering profile. Decorative metal and leaded-glass panels and metal door furniture add interest to the dark-stained design. The stencilled frieze draws directly from some of his book cover designs for Blackie.

The White Boudoir, about 1901
George Logan
Pencil and watercolour on canvas, glass beads
Given by the artist's family, 1983
E.1983.12.2

This fragile, fantasy Glasgow Style interior was displayed at the Exhibition of Modern Decorative Arts in Turin, Italy, in 1902. Logan experiments with materials and texture: watercolour is not an obvious medium for use on canvas. Sewn beads add texture to convey the droplets of glass in his pendant light fittings. The frieze design running above the picture rail appears to draw some inspiration from Mackintosh's 1892 watercolour *The Harvest Moon* (now in the collections of The Glasgow School of Art).

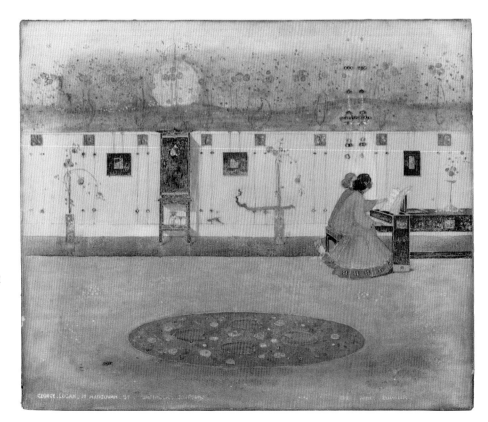

The Glasgow Style at International Exhibitions: Turin 1902

The profile of The Glasgow School of Art (GSA) and the Glasgow Style was raised abroad through two key exhibitions in 1902. Work was sent from the Glasgow International Exhibition to Hungary, and there was a very prominent, though loss-making, display of the Scottish Section pavilion at the Exhibition of Modern Decorative Arts in Turin, Italy. Newbery selected the works for exhibition, choosing largely designers and makers associated with Glasgow. Mackintosh designed the Scottish pavilion, creating three rooms: The Rose Boudoir, which he and Margaret furnished and decorated; A Lady's Writing Room by the McNairs; and a third space displaying work by some 50 designers and makers associated with the GSA. International opinion was mixed. At Turin, 'austerity verging on violent asceticism' said one critic, but frequent praise was given to 'the great activity shown by women, married and single'.

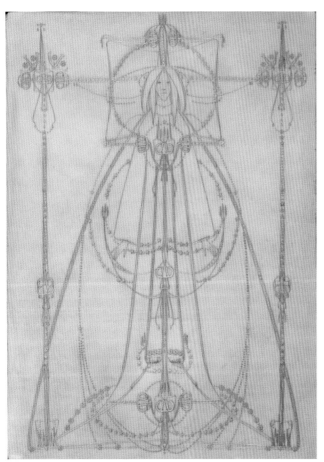

L'Evangile de L'Enfance de Notre Seigneur Jésus Christ, about 1900–01
Cover designed by Jessie M King; binding by Maclehose & Sons, Glasgow
Tooled vellum, gilt, hardbound printed paper
Bought by Glasgow Museums with assistance from the National Fund for Acquisitions and the Friends of Glasgow Museums, 2018
GML.2018.4.1

This gold-tooled book won King a gold medal at the Turin exhibition; she was the only designer in the Scottish Section to receive one. Her design of a female wearing a moth-like gown perfectly fills the cover without the need for borders. The craftsmanship of the gold-tooled vellum is breathtakingly crisp. The vellum binding was by Glasgow publishing family Maclehose & Sons. James, one of the sons, taught bookbinding and decoration alongside King at the GSA.

Embroidered portière, 1902
Jane Younger
Linen, silk
Given by a private donor, 1962
E.1962.10.a

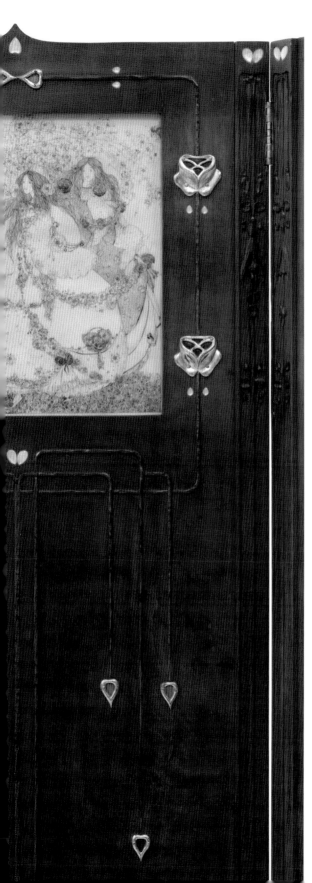

Folding screen, 1901–02

Designed by George Logan, made by Wylie & Lochhead, Glasgow, silversmith John A. Fetter; drawing, *The Princesses of the Red Rose*, by Jessie Marion King

Satin walnut, silver, mother-of-pearl, turquoise, red amethyst, white stone, leather, metal, glass, ink, watercolour and vellum
Bought by Glasgow Museums with the assistance of the Fraser Family Trust, 1986
E.1986.52

This richly decorated screen with carved margins of fuchsias won a silver medal at the Turin exhibition. Logan, its designer, worked at Wylie & Lochhead alongside EA Taylor (the fiancé of illustrator Jessie M King), with whom he ran the furniture department at the Glasgow and West of Scotland Technical College.

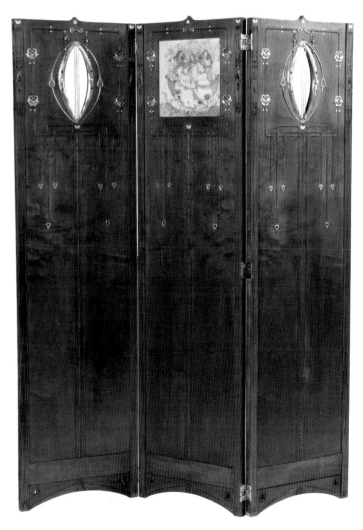

1901–1909:
MACKINTOSH'S MAJOR ARCHITECTURAL PROJECTS

1901: Mackintosh formally becomes an architectural partner in Honeyman, Keppie & Mackintosh.

1901: Mackintosh designs stencilled murals of stylized doves for Dysart Church, near Kirkcaldy in Fife.

1901: Mackintosh completes designs for his first major domestic commission, the house and furnishings of Windyhill in Kilmacolm, Renfrewshire. His client is William Davidson, who will be Mackintosh's greatest supporter throughout his lifetime.

1901: Mackintosh produces some interior designs and furnishings for 14 Kingsborough Gardens, a terraced house in Glasgow. The clients are shipowner Robert James Rowat – Jessie Newbery's cousin – and Mrs Jenny Rowat.

1902, March: *Dekorative Kunst* publishes a long, well-illustrated, article on 'the Glasgow art movement' by German architect Hermann Muthesius. In this the Mackintoshes are praised for their originality.

1902: Honeyman, Keppie & Mackintosh enter drawings for a 2-stage competition for the Anglican cathedral in Liverpool, but Mackintosh's entry is not selected for the second stage.

1902: Glasgow publisher Walter W. Blackie commissions Mackintosh to design The Hill House, a detached family house in Helensburgh. Blackie and his family move in in 1904.

The hallway at The Hill House, Helensburgh.

1903, 17 January: George Walton resigns from George Walton & Co. to pursue new design opportunities. The business struggles without him and is formally dissolved on 30 June 1905.

1903, February: The design of Miss Cranston's Willow Tearooms, Mackintosh's most luxurious and conceptual Glasgow tearoom, is underway. It opens to customers at the end of October.

Exterior of the Willow Tearooms.

1903, 22 June: The School Board of Glasgow appoints Mackintosh to design a new public school on Scotland Street in Tradeston, south of the River Clyde.

1903, 14 November: Mackintosh exhibits a bedroom interior in Germany at an exhibition organized by the Dresdner Werkstätten für Handwerkskunst (Dresden Handicraft Workshops).

1904: John Honeyman fully retires from Honeyman, Keppie & Mackintosh architects, though he had officially retired on 1 January 1901. Between 1902 and 1904 Honeyman focuses on the restoration of Iona Cathedral, the ruins of which Mackintosh and McNair had helped him survey in the 1890s.

1904: Mackintosh transforms the existing interiors of Catherine Cranston and her husband John Cochrane's large mansion house, Hous'hill in Nitshill.

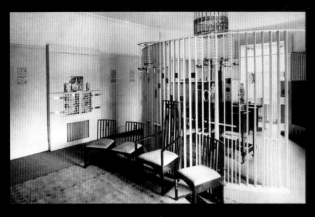

The Drawing Room and Music Room at Hous' hill.

1904: The work of Mackintosh, George Walton and EA Taylor features in the publication *Das Englische Haus* by Hermann Muthesius.

1905, February: Berlin furniture manufacturer AS Ball hosts and sponsors an exhibition of modern furniture. Mackintosh exhibits a dining room, George Walton a sitting room and library.

1906, 30 March: The Mackintoshes buy 6 Florentine Terrace, a mid-19th-century terrace house in Hillhead, Glasgow. (The address later changes to 78 Southpark Avenue.)

1906: Work begins at Cloak Cottage (also known as Mossyde) in Kilmacolm – a simple house in Scottish vernacular style.

1906, 4 August: Scotland Street School opens, significantly over budget. The initial roll is 391 children, but it can accommodate 1,250.

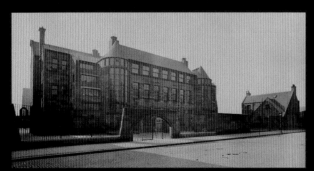

The exterior of Scotland Street School with Janitor's house.

1906, October: Mackintosh's Dutch Kitchen in the basement of Miss Cranston's Argyle Street Tearooms opens.

1906, December: Mackintosh is elected a fellow of the Royal Incorporation of British Architects (RIBA). He is elected Fellow of the Royal Incorporation of Architects in Scotland in 1908.

1907, February: Honeyman, Keppie & Mackintosh are appointed architects for the extensions to The Glasgow School of Art.

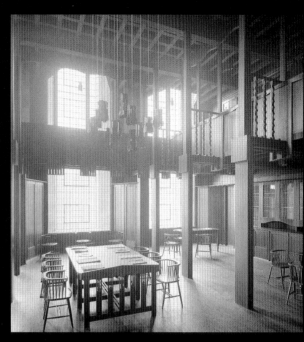

The Glasgow School of Art Library.

1908, June: After completion of the Oak Room and new basement Billiards Room at Miss Cranston's Ingram Street Tearooms, Mackintosh travels to Sintra, Portugal and sketches.

1908: The Lady Artists' Club commissions Mackintosh to freshen up their premises at 5 Blythswood Square, Glasgow.

1908: George Walton moves into architecture. He completes two very different buildings for his premier client George Davison: Plas Wern Fawr in Harlech, Wales, and The White House in Shiplake, Oxfordshire.

1909: Mackintosh designs a card room at Hous'hill. Interior decor and furniture is by Mackintosh and four small gesso panels of playing card queens are by Margaret.

1909, April: Chancellor David Lloyd George proposes a 'People's Budget' to fund the Liberal's new social welfare programmes. A 20% tax on the profit margin made when selling or inheriting land significantly reduces work coming in to architectural practices.

1909: Mackintosh designs interiors and furniture for the Ladies' Rest Room and the Oval Room at Miss Cranston's Ingram Street Tearooms. Work is completed in 1910.

1909, 15 December: The completed Glasgow School of Art formally opens.

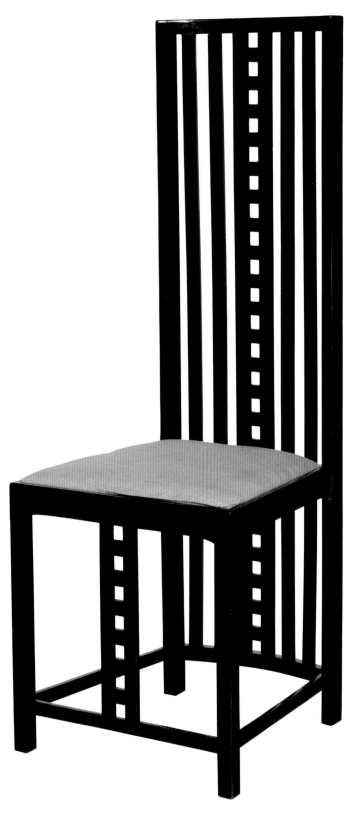

The Most Modern Interior
HILL HOUSE, HELENSBURGH

'Shake off all the props — the props tradition and authority offer you — and go alone — crawl — stumble — stagger — but go alone.'

Charles Rennie Mackintosh,
Lecture: Seemliness, 1902

What exactly makes Mackintosh's interiors so unique, so ultra-modern? It's their simplicity, purity, harmony, light, reduction, space, placement, proportion, rhythm, geometry, asymmetry, absence, contrast and counter-balance. The German language distills this into one word. *Gesamtkunstwerk* – a total work of art.

Tearooms gave Mackintosh a regular outlet to develop his ideas for furniture design and spatial transformation through interior decoration. A few wealthy patrons commissioned him to do the same for their personal living environments. His most luxurious designs were for The Hill House in Helensburgh, his domestic masterpiece and 'a dwelling house' – a family home – commissioned by publisher Walter W. Blackie.

Stencil card for the decoration of
the hall, The Hill House, 1904
Designed by Charles Rennie
Mackintosh; made by Guthrie & Wells;
commissioned by Walter W. Blackie
Card, paint
Bought by Glasgow Museums through
The Fine Art Society, 1984
E.1984.32.1

The five-colour stencil scheme of
the hall is the most elaborate in the
house. The black paint shows the
overall design; this card is marked and
cut for the chequerboard and droplet
elements of the tangled scheme.
Traces of olive green paint can be
seen around the cut areas and a rosy-
purple coloured paint can be seen in
the upper lines of the stencil. This is
probably therefore a test card, as the
paint colours edging the cut areas do
not match those in the final scheme,
which was pink for the chequerboards
with the droplets in bright green.

Facing Page:
Chair, first designed for the writing desk for The Hill House, 1904
Designed by Charles Rennie Mackintosh; made by Alex Martin, 1905
Ebonized wood, modern upholstery
Given by Mr W Somerville Shanks, RSA, 1940
E.1940.16.a

In the furniture he designed for the Willow Tea Rooms, Miss Cranston's home Hous'hill, and The Hill House, Mackintosh arranges evenly
spaced horizontal bars set between evenly spaced splats to create a variety of gridded patterns. Viewed straight on, the front and back
of this chair merge to form a perfectly aligned central column of squares, flattening the chair's depth. The severe bold design is subtly
softened with a curve: the rear seat rail sits forward of the tall, gently concave, back splats. This chair, though it matches the design for
The Hill House chair, actually has direct provenance from Mackintosh: it is the one Mackintosh had made for his own home. The Scottish
painter W Somerville Shanks purchased it at the Mackintosh Memorial Exhibition in Glasgow's McLellan Galleries in 1933 and presented
it to Glasgow Museums. This chair was the first piece of Mackintosh-designed furniture in Glasgow's municipal collection.

Exercises in Floral Arrangement

These works were made within a year of each other, and show Mackintosh taking three radically different approaches to floral forms worked up in very different mediums.

Stencil card for the decoration of a bedroom, The Hill House, 1904
Designed by Charles Rennie Mackintosh; made by Guthrie & Wells; commissioned by Walter W. Blackie
Card, paint
Bought by Glasgow Museums through The Fine Art Society, 1984
E.1984.32.4

This stencil card applied a reversed pair of carnations over the fireplace in a small bedroom in the east wing. The haphazard jagged edges of the petals are contrasted with the orderly chequered border. The card has been cut to accommodate both colours of the simple scheme of bottle-green and a dark, dusky pink. There are traces of a light blue paint under the pink, suggesting that this card was used for a different colour-way applied elsewhere in the building.

Panel from the standard lamp, The Hill House, 1905
Designed by Charles Rennie Mackintosh; commissioned by Walter W. Blackie
Silk, glass
Given by Mary Newbery Sturrock, 1953
E.1953.94

This appliqué panel is a surviving fragment from the original lamp; beads would have hung beneath from black ribbon. The black ribbon draws a bold framework, unnaturally ordering the stems and leaves, and cleverly delineating the veins in the leaves to add rhythmic curves. Nestled amongst the framework are two stylized roses, each head drawn with a single spiralling line. The colours have bleached over time through exposure to daylight, but traces of the pink silk flowers and lime green stitching can just be made out.

Faded Roses, 1905
Charles Rennie Mackintosh
Watercolour on paper
Given by the late George Sheringham and his wife Sybil Sheringham, 1938
2088

This early flower watercolour composition is a departure from the botanical studies Mackintosh made with his designer's eye. It could not possibly contrast more with the stylized roses he designed for the lampshade, and marks a transition in Mackintosh's nature study output in the early 1900s. His clever use of watercolour conveys the papery quality of the dried-out and decayed flower heads and leaves. The sadness emoted by this work is emphasized by the downward motion of the drooping plants and the vertically streaked black background.

The Most Modern Interior

HOUS'HILL, GLASGOW

In 1904 Mackintosh was commissioned to redecorate the interior of Hous'hill in Nitshill, Glasgow, the home of his patron, the celebrated tearoom owner Catherine Cranston (1849–1934) and her husband, John Cochrane. Although this project did not involve a great deal of construction, Mackintosh still managed to stamp his unique personality on the house interiors and designed many pieces of furniture. Miss Cranston moved out of the house after her husband's death, leaving behind all of Mackintosh's furniture. The house changed occupants several times before being badly damaged by fire in 1934, and was subsequently demolished. Mackintosh's furniture designs for Hous'hill are some of his most sophisticated. Thankfully many pieces had been sold at auction in 1933 and so survived destruction.

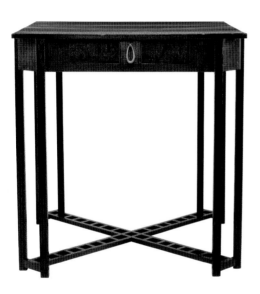

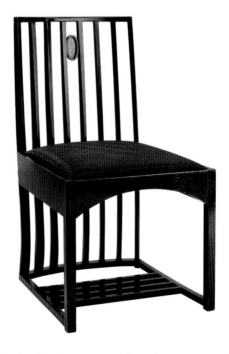

Card table for the billiards room, Hous'hill, 1904
Designed by Charles Rennie Mackintosh; made by Francis Smith
Stained oak and brass
Bought by Glasgow Museums with grant aid from the Heritage Lottery Fund, 2002
E.2002.5

A square wooden table with four legs – one at each corner – is usually a blocky looking item. Not in Mackintosh's hands! He lightens this one by reducing the bulk of its legs into two thin columns angled at 45 degrees to the table-top. Squares and very specifically placed not-quite-squares puncture the cross-stretchers and unusually draw visual interest to the floor level.

Chair for the drawing room and music room, Hous'hill, 1904
Designed by Charles Rennie Mackintosh; made by Alex Martin
Stained and polished sycamore; enamelled glass, modern upholstery
Bought by Glasgow Museums with grant aid from the Heritage Lottery Fund, 2002
E.2002.4

This chair is exceptionally subtle in design but complex in construction. Its fine back splats subtly taper and curve as they progress down from the top back rail, terminating into fine-bladed fins at floor level. It is one of four chairs Mackintosh designed to be set against the dividing screen in the drawing room. The drawing room's spacious interior was sub-divided into a music room by a curved vertically slatted screen, painted white; the curve of this chair back counterpoints the curve of the screen. The colourful oval glass drop was one of many appearing in the chairs and screen, and the overall effect was to suggest musical notes on staves – an appropriate theme for a music room.

The Square, The Grid, The Cube

In Mackintosh's interiors from 1903 we start to see his imaginative use of the square and its arrangement into grids and cubed structures. These shapes gave an architectural presence to his free-standing furniture, which were usually given a dark or ebonized finish. This furniture acted as counterpoints to the softer interior schemes, whilst linking to the tiny squares and grids appearing as two-dimensional decoration elsewhere within the room.

Stool for a dressing table for the blue bedroom, Hous'hill, 1904

Designed by Charles Rennie Mackintosh; made by Francis Smith
Oak, modern upholstery
Bought by Glasgow Museums with grant aid from the Heritage Lottery Fund, 2002
E.2002.6.a

This little stool is one of Mackintosh's subtler furniture designs. Looked at front on, its lower frame is a perfect square, drawn by the rails and legs. The seat pad intersects with the back splats to create a second row of five squares.

Stool for the Willow Tea Rooms, Sauchiehall Street, 1903

Designed by Charles Rennie Mackintosh
Oak, dark stain, horsehair upholstery
Commissioned by Miss Catherine Cranston
From the collections of The Glasgow School of Art
MC/F/44A

This sturdy cuboid stool shows Mackintosh taking the square as a design device to its most logical extreme in a piece of furniture design. Have a good look at this stool and see how many different squares, lattices, cubes – and very importantly not-quite squares – you see.

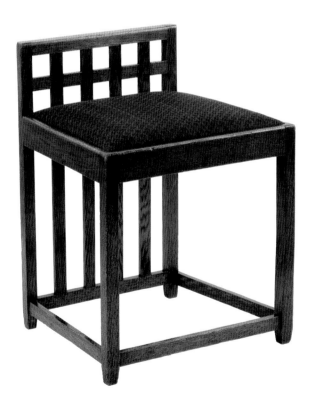

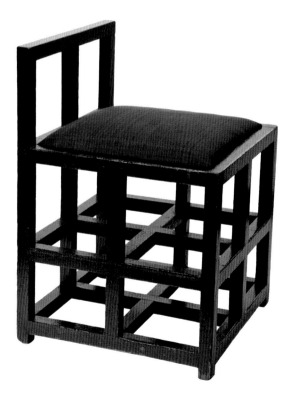

Architectural Masterworks

'…a building must be considered internally and externally as altering with every step you take. Now this necessity of giving a prophetic view of a non-existing structure requires <u>some</u> little artistic skill…These drawings…give but a very poor idea of what reality will be.'

Charles Rennie Mackintosh, untitled paper on architecture, about 1892

It was not cheap to build the buildings, or decorate the interiors, that Mackintosh constructed in his head. As he mentally walked around his creations to hone their three-dimensionality his detailing would have come into focus. Multiple drawings show him growing and refining his ideas. Between 1903 and 1909 he worked on two major projects for educational provision – Scotland Street Public School, and The Glasgow School of Art. Their complexity, sophistication, and his dogged determination to push boundaries and create something inspirational, make them his masterworks.

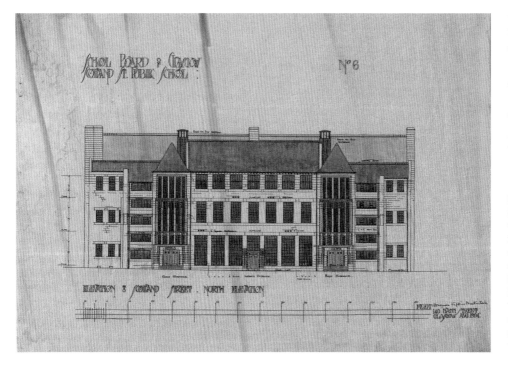

Scotland Street Public School, North Elevation, August 1904
Designed by Charles Rennie Mackintosh, 1903-4
Office drawing by Honeyman, Keppie & Mackintosh Architects
Ink and wash on linen
Glasgow City Archives
TD1309/A/520-6

Mackintosh's designs for this new public school pushed the School Board of Glasgow's brief and its budget. Leaded-glass windows, light-filled Scottish-Baronial stair towers, coloured-glazed tiles and carved stonework were not in his brief. What would have been in the brief would be to provide good daylight and ventilation, and to give separate entrances to the boys, the girls, and the infants.

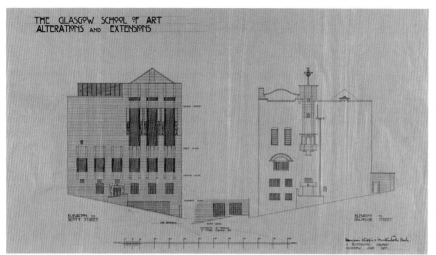

The Glasgow School of Art, East and West Elevations, June 1907
Designed by Charles Rennie Mackintosh
Office drawing by Honeyman, Keppie & Mackintosh Architects
Pencil, ink and wash on linen
Glasgow City Archives B4/12/2/1964-12

The new west elevation (coloured) shows how Mackintosh's approach to design had refined over a ten-year period. It is now much more forcefully geometric. Windows provide powerful vertical lines and horizontal bands of rhythm. Their intensity is amplified by the top-left plain almost-square area of stone wall and its beauty-spot window.

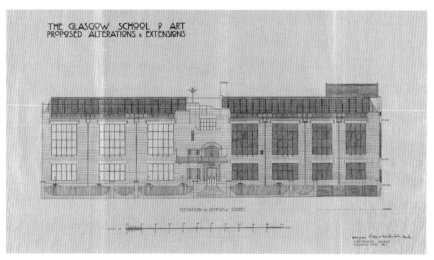

The Glasgow School of Art, North Elevation, June 1907
Designed by Charles Rennie Mackintosh
Office drawing by Honeyman, Keppie & Mackintosh Architects
Ink and wash on linen
Glasgow City Archives B4/12/2/1964-10

The coloured areas show the second phase of the School to be built. The first half, completed in 1899, is outlined. The deliberate asymmetry of the north facade as Mackintosh planned in 1897 is retained. Studios are added at roof level. In addition to new studio space, this second phase housed the striking new library (photograph on p. 69) and the basement lecture theatre (accessed externally through the door in the West elevation)

1910–1927:
TRANSITION, CHANGE, NEW DIRECTIONS

1910: EA Taylor and his wife Jessie M. King move to Paris. From March 1911 to 1915 they run The Shealing Atelier, their own private art school.

1911, 9 March: Talwin Morris, Art Director for publisher Blackie & Son, dies, aged 45.

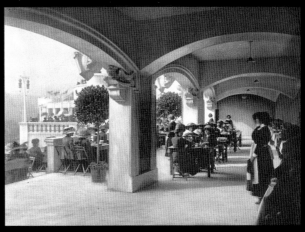

1911: Miss Cranston's White Cockade Tearoom designed by Mackintosh at The Exhibition of Scottish National History, Art and Industry.

1911: Ann Macbeth and Margaret Swanson publish *Educational Needlecraft.*

1912: Ann Macbeth is imprisoned, placed in solitary confinement and force fed; all for her commitment to the Suffragette movement.

1912: The Arts and Crafts Society Exhibition is a financial disaster. The workshop principle is struggling in an increasingly industrialized society.

1913, 31 December: Mackintosh leaves Honeyman, Keppie & Mackintosh. Keppie's financial review determined that Mackintosh was not bringing money into the practice. Keppie carries on under the name of Honeyman & Keppie, while Mackintosh sets up on his own, but fails to find any work. The partnership is formally dissolved in June 1914.

1914, July: The Mackintoshes leave Glasgow for Walberswick in Suffolk, England.

1914: Student numbers at The Glasgow School of Art drop significantly after World War I is declared and conscription for men begins. Many of the women volunteer for war work.

1911: Mackintosh designs the Chinese Room at Miss Cranston's Ingram Street Tearooms.

1911: Glasgow hosts its third international exhibition in Kelvingrove Park, The Exhibition of Scottish National History, Art and Industry.

1914: Dorothy Carleton Smyth returns to Glasgow after a successful career as a theatrical costume designer and takes up a teaching position at The Glasgow School of Art as Head of Commercial Art.

1915, 14 June: Mackintosh is banished from the counties of Norfolk, Suffolk and Cambridgeshire, because he has been reported to local Suffolk police as being a spy. Their house is searched and the police find old letters from Mackintosh's friends in Germany and Austria.

1915: The Mackintoshes settle in the well-established artists' quarter of Chelsea, London. They become part of a very active artistic and social circle, and each has a studio in Glebe Place. Mackintosh begins to paint watercolour compositions of flowers.

1915: The Mackintoshes design patterns for printed textiles for manufacturers Foxton's and Sefton's until about 1923.

1916: Mackintosh designs the interior decoration for 78 Derngate in Northampton, England.

1916, 1 July: The Glasgow School of Art's first professor of architectural design, Eugène Bourdon, is killed on the first day of the Battle of the Somme, France.

1917: Mackintosh designs the Dug Out, his last tearoom interior for Miss Cranston, in the basement of the Willow Tearooms.

1917: Francis H. Newbery, Director of The Glasgow School of Art, takes early retirement after 32 years' service, on medical grounds of overwork. He dies in Dorset in 1946 aged 92.

1917, 22 October: John Cochrane, husband of Miss Catherine Cranston, dies. She begins to sell off her tearooms. Buchanan Street and Argyle Street both close in 1918. She sells the Willow Tearooms on; it becomes The Kensington in 1919.

1918, 6 February: The Representation of the People Act gives all men over the age of 21, and those over 19 in the Armed Forces, the right to vote. Women over 30 years old who meet a property qualification finally get the vote, but full equal voting rights for women do not happen until 1928.

1920: Mackintosh designs a number of studios and studio blocks in Chelsea for individual artists and the voluntary organization The Arts League of Service. Only one of his proposals gets built, a studio-house for the painter Harold Squire at 49 Glebe Place. He designs an (unbuilt) theatre for the dancer Margaret Morris.

About 1920: Charles Rennie Mackintosh photographed by EO Hoppé in London.

1920: Jessie M King exhibits batik textiles in Indianapolis, USA, and in Paris. Liberty & Co., London, stocks her batik scarves, ties and fabric lengths. She publishes a book on the technique in 1924.

1921: Frances Macdonald McNair dies in Glasgow. Her husband, James Herbert McNair, survives her by 34 years, dying in Argyll in 1955.

1922: Margaret Macdonald Mackintosh and Jessie Marion King each contribute a small watercolour to Queen Mary's Doll's House project. This is Margaret's last known work.

1923, July–September: Mackintosh is listed as a lecturer in the programme for the summer school of friend and dancer Margaret Morris at Cap d'Antibes, in the south of France.

1924, 27 April: James Salmon Junior dies from cancer, aged 51. Two years later, his former practice partner John Gaff Gillespie dies. Their office will ultimately evolve into Gillespie, Kidd and Coia, one of the most innovative modernist architectural practices in post-war Britain.

1924–27: The Mackintoshes travel around many towns in the south of France and also further afield to Italy and Spain.

1925: The Mackintoshes stay for the first time in Port Vendres in the South of France.

1927, May–June: Margaret returns to London for financial and medical reasons. Whilst there, she promotes Mackintosh's watercolours to galleries. Her absence results in *The Chronycle* a series of letters from Mackintosh to his wife. This is the most personal body of correspondence to survive, revealing much about their tastes, interests, relationship and friendships.

1928, 10 December: Charles Rennie Mackintosh dies in London.

1933, January 7: Margaret Macdonald Mackintosh dies in London.

Transition, Change and New Directions

The demise of the Glasgow Style began about 1908; by this time some of its key practitioners had left the city to pursue creative adventures. Local opportunities dried up: Mackintosh failed to get another big architectural project after The Glasgow School of Art.

In 1911 Talwin Morris died. So too did William Forrest Salmon, which instigated the breakup of Salmon, Son & Gillespie. The McNairs suffered testing times with financial, professional and personal pressures. However, the seeds of change had been scattered. Mackintosh's designs slowly moved towards colourful patterns that pre-empted Art Deco. Some of the 'Glasgow Girls' forged successful careers at home and abroad, and at The Glasgow School of Art Ann Macbeth launched her Educational Needlecraft scheme, an influential teaching method. From now on, handicrafts would perpetuate the Glasgow Style through their use of its popular motifs.

In June 1914 the architectural partnership Honeyman, Keppie & Mackintosh was formally dissolved.

In July 1914, the Mackintoshes left Glasgow. World War I began and nothing was the same again.

Wall panel from The Cloister Room, Ingram Street Tearooms, 1912
Designed by Charles Rennie Mackintosh, 1911; woodwork by joiner James Grant; paintwork by decorator William Douglas

Umbrella holder and hooks by blacksmith R. Smith & Co.
Wood, varnish, paint, metal sheet, wrought and cast iron
Acquired by Glasgow Corporation, as part of the Ingram Street Tearooms, 1950
ISTR.3.N.12; ISTR.3.F.1.1 &.2; .2.1 &.2; .3.1–4

Mackintosh's last interior for the Ingram Street Tearooms, designed at the very end of 1911, was a redesign of one of his first interiors there. It is thought to have been used as a men's smoking room. Mackintosh transformed the space by adding a barrel-vaulted ceiling to contain large domed recesses that provided both air vents to the ventilation system and a framing device for pendant illumination. At the far end of the room, illuminated mirrored niches, fronted by carved fretwork, give a hint of Marrakesh. The walls were clad with wooden panelling, and the feature wall panels were stepped and stencilled with a wavy pattern coloured blue, green, red and white. This wave pattern motif featured around the room, above doorways, along the cornice, carved and cast into the plaster ceiling and wrought in iron.

Miss Cranston ran two cafés – The White Cockade and The Red Lion – at the 1911 Exhibition of Scottish National History, Art and Industry, the third great Glasgow exhibition to be held in Kelvingrove Park. Each café was given a title with a Scottish theme and a menu card designed by one of the Macdonald sisters. These cards are fascinating, not just for their design, but for the information they provide about Miss Cranston's suppliers, her bakery (she was her own cake supplier) and the food and drink she served there.

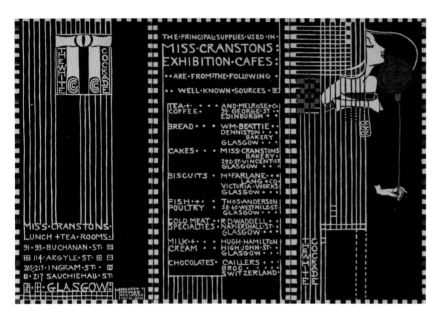

Menu card for Miss Cranston's The White Cockade Exhibition Café, 1911
Designed by Margaret Macdonald Mackintosh
Printed card
Given by a private donor, 2000
E.2000.13.1

Margaret's card depicts a stylized white cockade (the white ribbon of the Jacobites' cause) in the logo on the left-hand fold of the card. On the menu cover, a hint of chequered tartan in red, black and green can be seen to the left of the woman's shoulder.

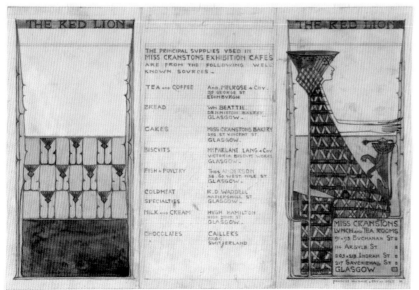

Menu card design for Miss Cranston's Red Lion Exhibition Café, 1911
Designed and executed by Frances Macdonald MacNair
Watercolour and pencil on vellum
Bought by Glasgow Museums with assistance from The Art Fund, National Fund for Acquisitions and Friends of Glasgow Museums, 2006
E.2007.1

Frances's design features two Scottish national emblems: the red lion and the thistle. Her female regally wears the flower as if it were both gown and crown – perhaps referencing that the Lion Rampant flag is the Royal Standard of Scotland.

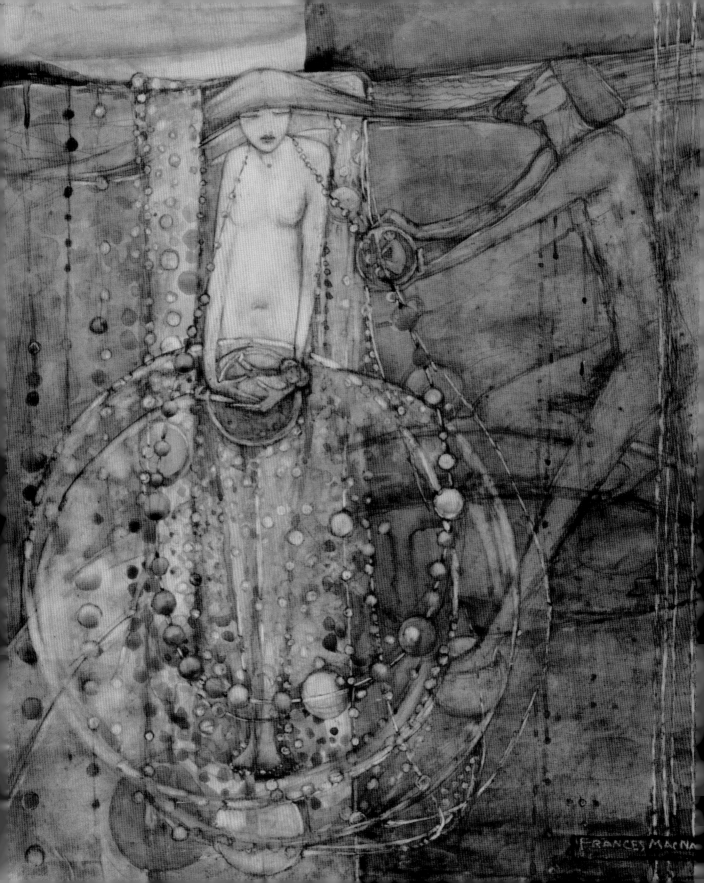

Facing page:
Man Makes the Beads of Life but Woman Must Thread Them, **after 1911**
Frances Macdonald MacNair
Pencil, watercolour, gouache and gold paint on paper
From the collections of The Hunterian, University of Glasgow
GLAHA 41284

Around 1911 Frances paints the most intense, psychologically charged, series of watercolours of her life. They no doubt reflect her and McNair's personal turmoil – in 1909 her husband's family went bankrupt, leaving him heavily in debt; his professional career in Liverpool came to an end, and he turned to drink. The McNairs moved back to Glasgow and Frances worked as a design instructor for metalwork and needlework at The Glasgow School of Art. In 1912 Frances's and Margaret's mother died, and McNair left, or was banished by her family, to Canada for two years. This was clearly the most distressing of times for her, and it appears that she used her art to channel and express her feelings. One noticeable element uniting these watercolours is her depiction of the main female figure; always in physical isolation or consciously detached from the other individuals depicted.

Frances McNair died in Glasgow on 12 December 1921, aged only 49, by her own hand, according to some testimonies. McNair, distraught, gathered together as much of their artwork as he could and destroyed it. He never made art again.

Educational Needlecraft

Ann Macbeth's teaching scheme for the Art Needlework Diploma she and Margaret Swanson developed at the GSA was published as *Educational Needlecraft* in 1911. This book presented a graded teaching scheme for needlework instruction for all children from the age of six to 14, with the application of embroidery and appliqué up to 24 years old.

Macbeth declared her scheme '...an epoch in its ingenuity and invention and in its consideration for the development of the child, which should go far to make needlework in our schools not merely a craft, but a National Art'. Fra Newbery described its uptake around the country, and Empire, as a 'Movement'. After the success of *Educational Needlecraft* – which was taught in schools for more than 50 years – Macbeth, a tireless educator, wrote a further five books on the homecrafts including leatherwork and rug weaving. She taught at the GSA until 1928.

Handkerchief sachet, about 1910
Designed and made by Eliza C Kerr
Silk, kapok
Given by Mrs MD Hutton, 1981
E.1981.18.2

This silk pouch was designed and made by Eliza Kerr, attending Macbeth's Saturday Needlework classes for art teachers at The Glasgow School of Art between 1905 and 1910. During the week Kerr was a teacher of children with physical disabilities at Shields Road Public School on Glasgow's south side. Teachers attending the Saturday classes applied the course methodology to create their own pieces of needlework. At the end of two years they were assessed on their designs, a satchel of work and an examination piece.

Bag, worked from *Educational Needlecraft*, Lesson II, after 1911
Designed and made by Janet McKim
Linen, silk, textile
Given by the artist's family, 1980
E.1980.176.2

The Glasgow Style palette had long-favoured the greens, purples and whites used to sew this little bag. Needlework tutor Ann Macbeth had always maintained that these colours were kind on the eyes, and so beneficial for young children to work with. However, these colours also identified with the Suffragette movement – and the ladies of the Needlework Department were keen supporters of the cause!

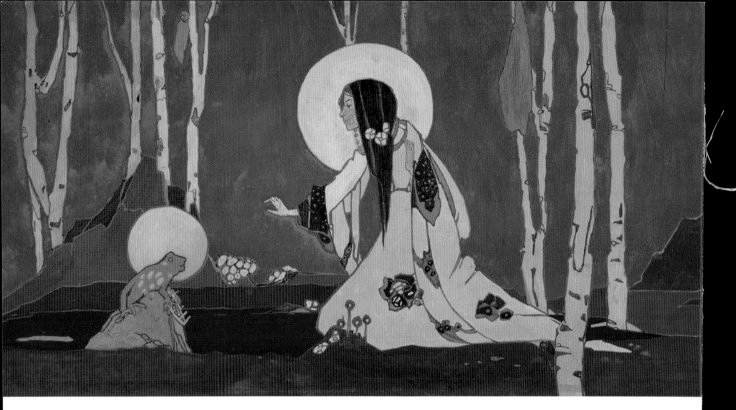

The Frog Prince, 1913
Jessie Marion King
Oil on panel
Bought by Glasgow Museums with the support
of the Heritage Lottery Fund, 2004
E.2005.1.53

In 1913, whilst living, working and teaching in
Paris, King was invited to display work at the
exhibition *Art for Children* at the city's Musée
Galliera. She designed 'A Modern Nursery'; an
entire nursery interior, with toys, a doll's house,
child-size furniture and a leaded-glass window
with a woodpecker design. This panel was one
of four panel paintings that lined the walls above
bookcases and told the fairy tale.

Paris gave King many opportunities. There
she was introduced to the technique of batik
which, suiting her freer, painterly style, became
a passion, a commercial success and influenced
her illustrative style. Mimicking the effect of
drawing with a wax resist and working with
bright coloured dyes she began to draw lines in
white – an absence of line – between a bolder
use of blocks of colour. She and her husband
Taylor returned to Scotland after the outbreak of
World War I, living and working in Kirkcudbright,
Dumfries and Galloway. She continued to be
a prolific book illustrator and designer and
exhibited widely. By the end of her professional
career she had worked on more than 200 titles.

The Rambler Travel Books:
The British Isles, 1913
Cover design by Charles
Rennie Mackintosh;
published by Blackie and Son
Limited, Glasgow
Woodblock print on cloth
Given by Walter W Blackie,
1944
PR.1977.13.ak.2

It was only after Talwin
Morris's death that
Mackintosh was invited
to create book covers for
Blackie. His designs for these
series titles reflected the
subjects – here, an energetic
line drawing of trees in the
countryside for travel.

Programme for The New Cinema, Sheffield, 1913
Designed by Ann Macbeth
Printed paper
Lent by Andy Mitchell

Possibly as a result of her travels around England lecturing on the Educational Needlecraft scheme, Ann Macbeth was appointed the interior designer for a new Cinema House in Sheffield sometime between 1911 and 1912. Working with architect JHE Farmer, who conjured a Jacobean themed interior with oak panelling and decorative plaster ceiling, she contributed designs for tapestry hangings, woven carpets, repoussé metal doorplates and leaded-glass – which was remarked upon as 'a feature to be observed'. The printed programmes, menu cards and all printed matter for the cinema were designed by Macbeth and described as being in keeping with her design and colour scheme throughout the theatre.

The "Saucy May", about 1922
Cover designed by Charles Rennie Mackintosh; published by Blackie and Son Limited, Glasgow
Printed cloth hardcover
Special Collections, The Mitchell Library 900764

This strong book cover design derives in part from the stepped wall panelling of the Cloister Room (Ingram Street Tearooms) and its applied decoration. Design is an exacting exercise in proportional calculations to achieve the perfect effect. An early design drawing for this series title saw Mackintosh allocating a square for the title box. The box was made wider in the final design so the title typography would fit.

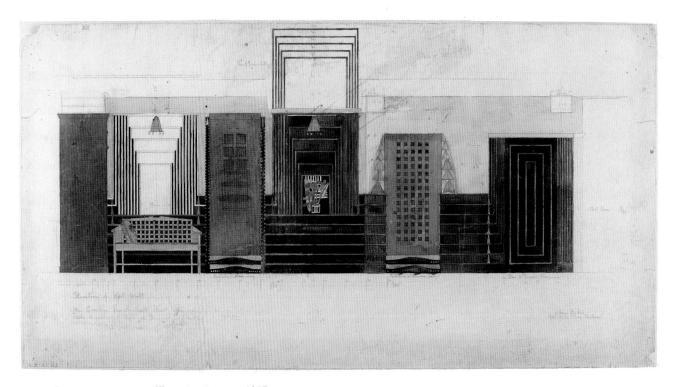

Design for The Dug-Out, Willow Tea Rooms, 1917
Charles Rennie Mackintosh
Pencil and watercolour on paper
From the collections of The Glasgow School of Art
GSA MC.G.49

Designed and built over the same time period as Derngate in Northamptonshire, this basement extension to the Willow Tea Rooms employed a similar riot of bold lines and colour. The design of the stepped wall panelling takes ideas from the Cloister Room of 1911, but Mackintosh has now replaced all wavy lines with strong verticals and horizontals. The Dug-Out and Derngate were Mackintosh's last major commissions, and his most devastatingly modern interiors.

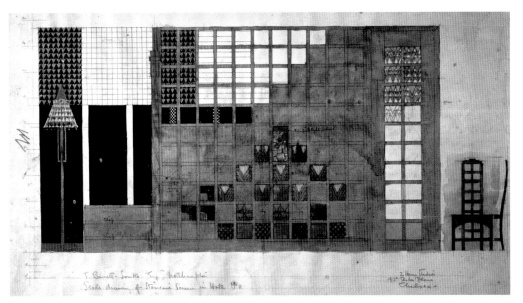

Design for the Lounge Hall, 78 Derngate, Northampton, 1916
Charles Rennie Mackintosh
Pencil and wash on paper
From the collections of The Hunterian, University of Glasgow
GLAHA 41104

Completed in 1917, Derngate's tiny lounge-hall was Mackintosh's boldest interior thus far. Black gave a feeling of space. Applied design, mostly shades of yellow, was constructed by squares and triangles. Only one panel had wavy lines.

Three Designs for Street Standards, about 1915–18
Charles Rennie Mackintosh
Watercolour, ink and pencil on paper
From the collections of Strathclyde University Archives
GB 249 T-GED/22/1/India/1413/3

These electric lights, designed using triangles and squares, may have been destined for Patrick Geddes's innovative work to improve urban design in India. Mackintosh created some designs for his long-time friend, but declined to travel.

Textile Design: Wave pattern, purple and black, about 1915–23
Charles Rennie Mackintosh
Pencil and watercolour on paper laid on cream paper
From the collections of The Hunterian, University of Glasgow
GLAHA 41476

Mackintosh first used the undulating wave form through the application of wavy lathe to his furniture. He gradually distilled it into a two-dimensional pattern in the Cloister Room in the Ingram Street Tearooms. Here it has evolved into a variety of pattern and ideas.

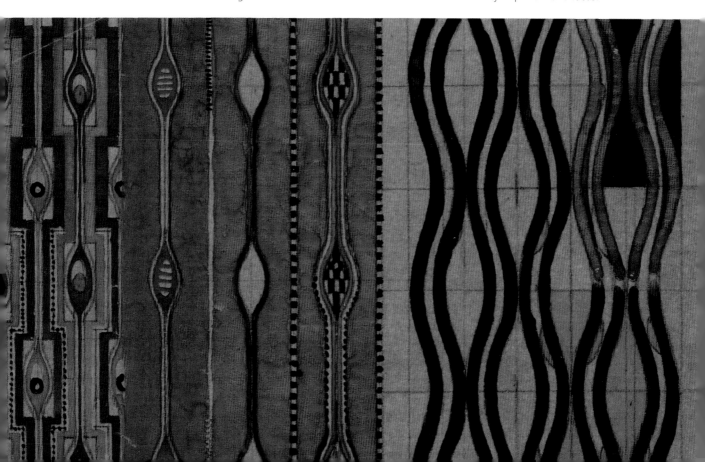

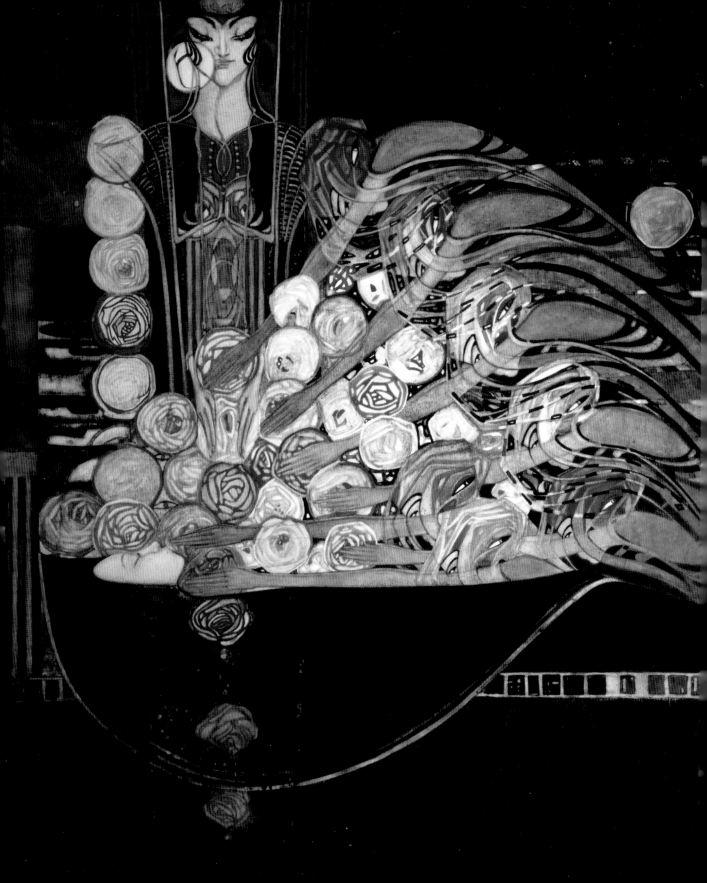

La Mort Parfumée (The Perfumed Death), 1921
Margaret Macdonald Mackintosh
Pencil, watercolour, gouache and gold paint on paper
From the collections of The Hunterian, University of Glasgow
GLAHA 41288

This dramatic watercolour depicts the climax of the 1913 Symbolist and Orientalist play, *La Pisanelle, ou La Mort Parfumée*, by Italian playwright Gabriele d'Annunzio. The dancing 'heroine' is pushed to her death by a group of Numidian slaves; they suffocate her under a pile of rose petals. Her perfumed death. The play was first performed in Paris in 1913 with sets by Russian designer Leon Bakst.

Textile Designs

Good repeat patterns have a rhythm, a pulse. They can possess a vibrant energy or a calming refined elegance. Choice of colour, size of details, dynamism of line, direct the mood each conveys.

Between the years of 1915 and 1923, whilst based in London, Mackintosh created many fabric designs for textile manufacturers Foxton's and Sefton's. Pattern preoccupations include bold florals; wavy lines; chequerboards, squares and triangles – their subdivision and arrangement – and the contrasting potential of organic, undulating wavy lines. A few surviving drawings from this period suggest Mackintosh devised some decorative patterns for ceramic plates. It is not established if any went into production; if they had been made within his lifetime, his bright Art Deco-esque designs would have pre-dated Clarice Cliff.

These works reveal the pattern-making process. The paper is gridded up and the structure of the repeat applied in pencil before the design is worked up in watercolour.

Textile design: Odalisque, about 1915–23
Charles Rennie Mackintosh
Pencil and watercolour on paper laid on cream paper
From the collections of The Hunterian, University of Glasgow
GLAHA 41500

In 1904, Mackintosh had sketched a stencil scheme for Miss Cranston's dining room at Hous'hill. That design appeared to suggest the naked torso of a young lady emerging from stems and clusters of flowers. More than ten years later, Mackintosh revisited the design, modifying the woman's rose-covered torso into a repeating pattern for textiles. He also tried out different treatments for the background patterns to unify the bodies.

Textile design: Wave pattern: purple, pink, orange and black, about 1915–23
Charles Rennie Mackintosh
Pencil and watercolour on paper
From the collections of The Hunterian, University of Glasgow
GLAHA 41485

Using symmetry Mackintosh here creates a brilliant optical illusion. The white, purple and orange loops are all aligned vertically against the pencilled grid but the wavy arcs of pink and black create strong diagonals that distract the eye away from the underlying structure of the pattern. The coloured boxes in the bottom left-hand corner suggest alternative colourways for the fabric.

Flower Studies

Mackintosh and Margaret never returned to work in Glasgow after the War. They remained in London, working and making friends with those in the arts scene there.

For Charles, the watercolour painting of compositional flower studies became an increasingly important pursuit from about 1916. Some were exhibited internationally in Detroit and Chicago. Sometimes the flowers are set within a room, sometimes against a highly patterned background either incorporating or channelling his textile designs. These two watercolours in Glasgow's collection have the focus fully on the cut flowers and the ceramics that contain them. He carefully places ceramics and glass to balance the composition.

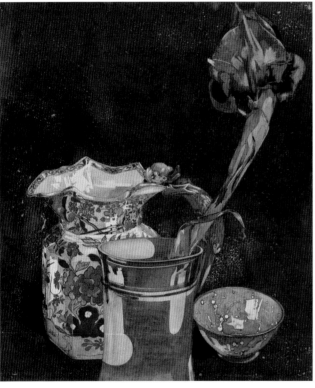

Grey Iris, about 1923
Charles Rennie Mackintosh
Pencil and watercolour on paper
Bought by Glasgow Museums from the Mackintosh
Memorial Exhibition, 1933
1855

This flower study is an exercise in subtlety, reflected light and tonal variation. The grey iris of the title is actually a black iris; the glossy undulating surfaces of its petals reflect light to reveal greys and purples. Mackintosh enjoys capturing the play of the light reflecting across the high-gloss glazes of the Oriental ceramics. The largest vessel is an Imari-ware patterned jug, popular in Britain in the late nineteenth century. The curve of its handle formed by a grotesque with a snake-like body counters the curve of the iris stem perfectly.

Pinks, about 1923
Charles Rennie Mackintosh
Watercolour on paper
Given to Glasgow Museums by John Sawers, 1941
2247

'Pinks' is the colloquial, collective name for delicate, small-headed, flowers from the dianthus and carnation family of plants. Mackintosh's watercolour studies their variety and diversity and paints their intense floral palette; the pinks, purples and reds are offset by the pastel blue and green tones of the stems. He particularly pays painstaking attention to the jagged edges of the petals, rendering this examination of nature with a mind-boggling crispness.

End Days

In 1923 the Mackintoshes made the first of many long visits to the South of France. Mackintosh, almost obsessively, painted its landscape. But Margaret's health faltered and Charles fell ill. Upon their return to London he was diagnosed with inoperable cancer of the tongue.

After a long, drawn-out protracted illness, experiencing radium therapy at Westminster Hospital and his speech restricted, Charles Rennie Mackintosh died on 10 December, 1928, in a nursing home in London. He was cremated at Golders Green. Talwin Morris's widow Alice was one of the few people to attend his funeral.

After his death Margaret travelled around the south of France for two years, returning to Port Vendres which clearly had so many special memories for her. She described this in a letter to her friend, the dancer Margaret Morris: 'there is no place that I have found yet – which gives one so much pleasure as Port Vendres'. In May 1931 on the expiration of her visa she visited Monaco before returning to London. On 7 January 1933 she died of cardiac asthma in a London nursing home. She had survived her husband by just over four years.

Following Margaret's death, a Memorial Exhibition was held in May 1933 at the McLellan Galleries in Glasgow as a celebration of the Mackintoshes' life and work. The exhibition was organized by businessmen James Meldrum – whose father Willliam had studied alongside Mackintosh at the GSA – and William Davidson, who commissioned Windyhill. Works were lent and some were for sale. The catalogue foreword was written by Jessie Newbery.

Sadly, 1933 saw the passing of some other immensely talented individuals associated with the Glasgow Style. Designer and architect George Walton died exactly five years to the day after Mackintosh. In February Dorothy Carleton Smyth was appointed Director of The Glasgow School of Art. She would have been the first woman to hold the position but tragically died of a cerebral haemorrhage before she was able to take up the post. We can only imagine what such a talented polymath, commercial designer and educator would have brought to the leadership of the School at that time.

Margaret Macdonald Mackintosh, about 1929.

Port Vendres – La Ville, about 1925–26
Charles Rennie Mackintosh
Watercolour on paper
Bought by Glasgow Museums from the Mackintosh
Memorial Exhibition, 1933
1856

The Mackintoshes regularly stayed in the small
French town of Port Vendres, a port very near the
Spanish border which hosted a main shipping
route to North Africa. Mackintosh painted many
watercolours of the town and the quay. He captures
here the higgledy-piggledy arrangement of the local
architecture – simple white façades, sloped roofs
– countered by the geometric placing of windows.
The quayside hotel he and Margaret resided in when
there – the Hôtel du Commerce – is visible to the
left of this painting. It is recognizable by the large
projecting awning casting a pronounced shadow.

The Village of La Llagonne, about 1925–26
Charles Rennie Mackintosh
Watercolour on paper
Bought by Glasgow Museums, 1960
PR.1960.24

The Mackintoshes stayed in a number of small
towns in the south of France over a four-year
period. Locations visited include Amélie-les-Bains,
Ille-sur-Têt and Mont Louis. Mackintosh painted
sitting on a three-legged stool, his watercolour
board propped on his knees. To ensure consistency
of light, he would work at the same spot at the
same time day after day. This work is a composition
rather than a true view – Mackintosh has brought
two local features closer together for a more
dramatic perspective.

Epilogue

Over two decades – from the early 1890s to the close of the 1900s – the Glasgow Style burned brightly. A blackened industrial city in the West of Scotland led on the production of an influential new design language. Many individuals were important in contributing to the development of its individual parts, its motifs, its diversity, its evolution and its spread.

After the death of Margaret, those that knew Mackintosh summarized in personal tributes their memories and understanding of what drove him. All spoke of his reception and veneration by progressive contemporaries in Europe; all were saddened by what work had already been lost within Glasgow. And all spoke of what set him apart from the rest; of his genius.

It was Mackintosh's move away from the two-dimensionality of the Glasgow Style, onto his personal trajectory of the 1900s, that stands at the very centre of its success and legacy. His purist, mathematical, musical and analytical mind distilled ideas; be they from Scottish traditional forms, Japanese simplicity, Nature, or from his friends and contemporaries. Dialogue and conversation with others was important. A life-long artistic dialogue with his wife Margaret Macdonald nourished him.

Mackintosh's genius was in his grasp and rationalization of all of these elements, and an understanding of the emotional power they could have on the human experience in three-dimensions. Severe plunging verticals. Rhythm by repetition. Minimalism. Taut curves, piercings and colour always expertly placed to soften. His architecture and interiors – his total works of art – are a potent directing of eye, mind and space. It is for this that many regard him as the father of Modernism.

Please now go and experience Mackintosh three-dimensionally. Across Glasgow, in Helensburgh and Dysart, Northampton: there are many collections, buildings and restored interiors that you can, and must, go visit.

Catalogue for the Mackintosh Memorial Exhibition, 1933
Paper, ink
Given by James Meldrum, 1938
Special Collections, The Mitchell Library
1,000,992 MC/5

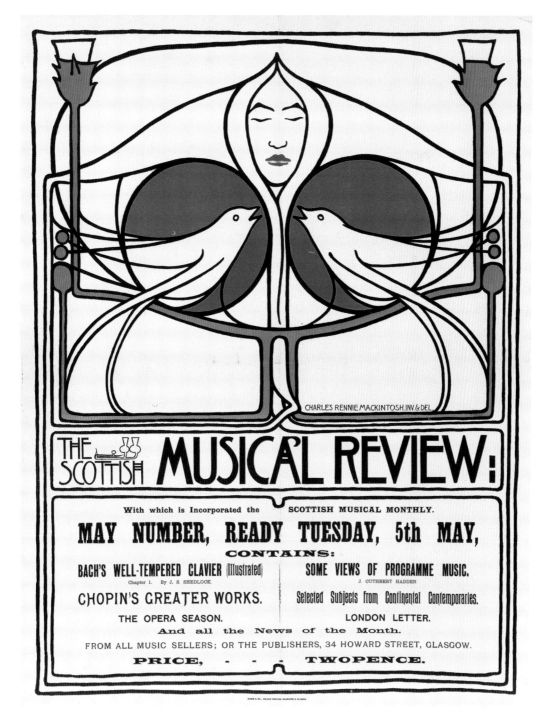

Poster for *The Scottish Musical Review*, May edition, 1896
Designed by Charles Rennie Mackintosh; printed by Banks & Co.,
Edinburgh and Glasgow
Planographic, lithographic, print on paper
Given by Mrs Alice Talwin Morris, 1946
PR.1977.13.aj

'Before my husband and I knew C.R.M. and Margaret Macdonald some years before their marriage (about 1894-5) when he was with Messrs. Honeyman and Keppie and she shared a studio in Glasgow with her sister Frances (later Mrs Herbert McNair). She used frequently to meet C.R.M. and other artists of more-or-less like mind at this studio, and later on when the Macdonalds took our house (Dunglass) at Bowling and we moved up to a cottage on the hill above that village, we saw a good deal of each other, and C.R.M. ('Tosh' as he was called among us) sometimes stayed at our house. He was one of the straightest, sincerest, and simplest people I have ever known (like his work) and a tremendous lover of beauty in all forms – in nature, in faces, in character, in forms of speech, and ways of thought, etc. A strong hater he was too, of everything that seemed to him showy and shoddy, or false or unsound, or founded on mere convention of custom of opinion; and quite uncompromising in his opposition to what he felt wrong – or at any rate <u>not</u> right.

A quiet and rather shy man generally, he was a keen and untiring talker when his interest was roused. I have many memories of immensely long talks in our home which went on into the 'small hours'. Sometimes I was conscious only of the latter part of these only as a murmur of voices from below which reached me through the floor of my bedroom. He was particularly antagonistic to the idea (then more prevalent than now) that the outstanding work of artists of the past – however beautiful – should be considered as the only right standard of beauty for following ages. I am sure he was second to none in his respect and admiration for good art of the past (I have often heard him speak enthusiastically of this – especially of great architecture) but he always contended very strongly that every age has its own spirit to express, its own truth to tell, and that no trammels of set opinion or fixed standards of beauty should ever be allowed to fetter the freedom of an artist to express himself. He was of course (like many great people) ahead of his age, and so he suffered more perhaps than most from the restrictions of his day, and from the lack of understanding and consequently of appreciation – of many of his contemporaries.

He did – as you will know – gain admiration and found fame in some Continental countries and was acclaimed as a pioneer in Architecture – especially of the Scandinavian Architecture of his day – and this I know was a source of encouragement to him and his wife (always his understanding collaborator). You will probably have heard of the Annual Meeting (with a dinner) of the Continental Artists of that day, held I believe in Holland, soon after he died at which contrary to custom one toast only was proposed and drunk in silence, to Charles Rennie Mackintosh.'

**Extract from a letter to Dr Tom Honeyman,
Director of Glasgow Museums and Art Galleries,
from Alice Talwin Morris, 20 October 1939**
GMA.2018.1.12